# *Practical*
# WATERCOLOURS

## MATERIALS, TECHNIQUES & PROJECTS

*Curtis Tappenden*

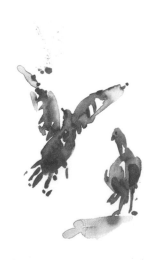

**Ivy Press**

For Susanne

This edition published in 2015 by
**Ivy Press**
210 High Street, Lewes,
East Sussex BN7 2NS, UK
www.ivypress.co.uk

This book was conceived, designed,
and produced by
**Ivy Press**
Creative Director: Peter Bridgewater
Publisher: Sophie Collins
Editorial Director: Steve Luck
Designer: Clare Barber
Page Make-up: Richard Constable
Project Editor: Caroline Earle
Picture Researcher: Vanessa Fletcher

British Library Cataloguing-in-Publication Data
A catalogue record for this book is available from
the British Library.

ISBN: 978-1-78240-241-1

Colour origination by Ivy Press Reprographics
Printed in China

10 9 8 7 6 5 4 3 2 1

Distributed worldwide (except North America)
by Thames & Hudson Ltd., 181A High Holborn,
London WC1V 7QX, United Kingdom

# CONTENTS

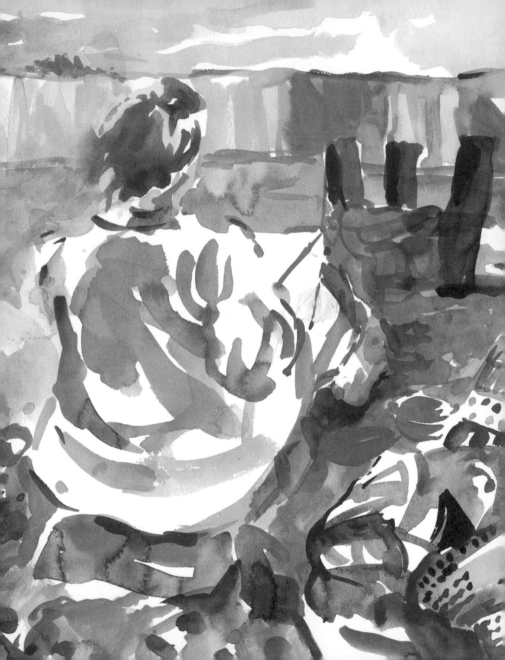

# GETTING STARTED – KEEPING A WATERCOLOUR SKETCHBOOK

Recording visually the world in which you live is one of the most challenging and rewarding forms of learning. For centuries, artists have favoured watercolour as the medium in which to keep a sketchbook. It is one of the most convenient media in which to work, and has the range and adaptability to suit virtually any kind of painting style or situation. Just a few sparkling washes of colour can breathe life into a rapidly executed pen or pencil sketch, and a fluid brush drawing can capture the mood of the moment with ease. You will soon find yourself filling pocket sketchbooks with compositional notes and ideas for larger paintings, snapshots from your travels and studies of familiar objects or unfamiliar places. With just a little experience of how the medium works, you will be able to look at examples both in this book and beyond and pick up useful practical information to assist you on a new visual journey.

# CHOOSING PAPERS

Watercolours can be painted on any paper strong enough to take the flooding of diluted pigment. The effect will very much depend on the quality and texture of the paper used. For the best results, use special watercolour papers, which, although more expensive, will give your work a satisfying, professional look. Amazingly, their high-quality manufacture has changed little since the eighteenth century.

Toned papers require a different approach to painting, where the whites need to be added in later.

## PAPER THICKNESS

The thickness of paper is measured in grams per square metre (gsm or g/m2) so a 128-gsm paper is very thin and a 640-gsm paper is very thick. When buying, you can choose from loose sheets, pads or blocks bound on all sides, which require no stretching before use.

Whenever you buy a new paper, remove a small strip and write the make, texture and weight of the paper on it for future reference.

✻ **CARTRIDGE** paper is the cheapest watercolour paper. Its smooth surface and durability make it very popular. Paint sinks into it quickly and the wrinkling will make your drawings look fresh.

✻ **HOT PRESSED (H.P.)** paper is pressed under steam-heated rollers. The slippery surface is not good for subtle effects but excellent for detail work and line and wash.

✻ **COLD PRESSED (C.P.)** paper has a fine or semi-rough grain when pressed under cold rollers, permitting large flat washes, rough textures and fine detail on the same sheet. It is also known as NOT - 'not hot pressed'.

✻ **ROUGH** paper has, as its name suggests, a definite 'tooth' resisting the drag of the brush. Pigment fills the lower paper surface, creating a white speckled effect above. Achieving a full range of techniques is difficult on rough paper.

✻ **HANDMADE** papers are of the best quality and are mainly produced from pure linen. Their high absorbency requires confident, skilful handling to master the art.

✻ **ORIENTAL** and **ORGANIC** papers, created from plant sources, are highly absorbent. Their various colours and textures help remove any inhibitions, making them great fun to experiment with.

# CHOOSING COLOUR MATERIALS

*A visit to the local art shop can be a revelation. Shelves stacked high with tubes, brushes, pencils and pads of all shapes and sizes can leave you daunted and wondering what to buy. There are no rules, but sound advice is to buy only what you need and purchase the best you can afford.*

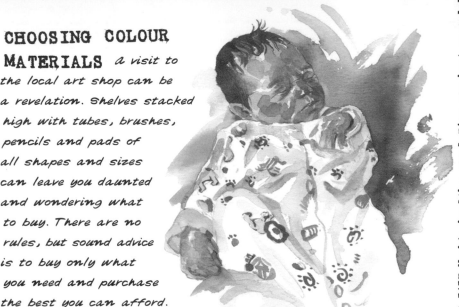

* BABY Noah's healthy complexion was best recorded in watercolour when he was only a few hours old.

**WATERCOLOURS** *sold in block form are known as pans and half pans, and come in boxed sets or as individually wrapped items. Tubes are excellent when you need to mix up larger quantities of paint, but be aware that vibrant, liquid colours in bottles may be 'fugitive' (short-lived) and fade in strong daylight.*

**GOUACHE,** *or 'body colour', is watercolour with zinc white added, making the pigment flat and opaque. The painting process can be used the other way around, from dark to light, and is perfect for adding highlights or working on toned papers.*

*Simply splashing around wet-in-wet in a spare moment is invaluable in developing your skills.*

**INKS** are bottled and available in all colours. They cover large areas quickly and can be spattered, blown or used with a nib pen to great effect. With the exception of black, they tend to be fugitive and cannot be manipulated when dry.

**AQUARELLE PENCILS** are water-soluble. When wetted, the lead gently crumbles into pigment, which can be repeatedly drawn into, wet or dry. These pencils are useful on rapid sketching trips where a watercolour box may be inconvenient.

**OIL PASTELS**, **CHALKS** and **WAX CRAYONS** all complement watercolour in the techniques of resist, with pigment resting only where they have not been used.

**FELT-TIP** and **FIBRE-TIP PENS** are mainly non-waterproof, so the hard edges of a line and wash drawing can be softened with a brush, giving it depth through tonal qualities.

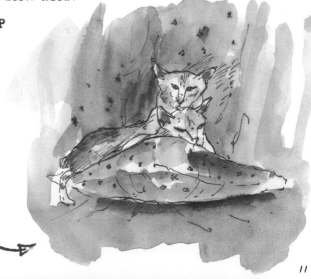

✳ CAPTURE homely feline attitudes with the delicate lightness of fibre-tip pens and muted washes.

**TOOLS** There are many different painting tools to choose from, each one specifically designed for a particular job. The abundant choice of equipment makes life very simple for the watercolourist. As you become more ambitious, you may wish to add a few new brushes to your kit, or perhaps a bigger palette might come in handy for mixing larger quantities of paint. Whatever you decide, take your time to choose carefully so that you do not make bad purchases.

Get acquainted with the names of brushes and the type of hair they are made from. Sable is the most expensive, followed by ox, squirrel, mixed fibres and synthetic. When choosing a brush, check that it can be rolled to a fine point when dampened. If the point splits or the brush lacks springiness, then it will have neither good paint-carrying capacity nor the ability to produce a diverse range of strokes.

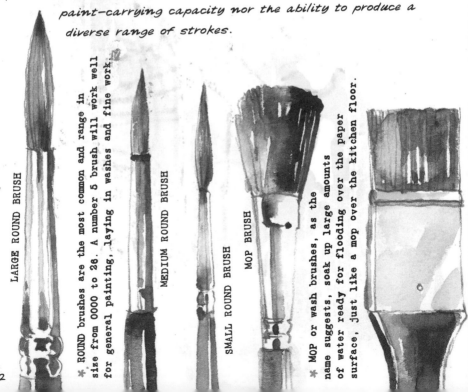

LARGE ROUND BRUSH

MEDIUM ROUND BRUSH

SMALL ROUND BRUSH

MOP BRUSH

* ROUND brushes are the most common and range in size from 0000 to 26. A number 5 brush will work well for general painting, laying in washes and fine work.

* MOP or wash brushes, as the name suggests, soak up large amounts of water ready for flooding over the paper surface, just like a mop over the kitchen floor.

**CARE OF BRUSHES** *Rinse brushes in warm, soapy water, bringing them to a point between your fingers. If you do not have soap on hand, spit works equally well! Never stand brushes on the hair end; this will push them out of shape.*

**OTHER USEFUL TOOLS** *These include small sponges, a soft putty eraser, paper towels or tissues for 'lifting' colour; a small candle and some salt for use as resists; and a blowdryer, which may save you drying time. Cutting and scratching out are best undertaken with a retractable craft knife or surgical scalpel. Carry two waterpots – one for fresh water, the other for waste.*

## USING OLD BRUSHES

*Keep old decorating brushes, toothbrushes and makeup brushes, which can all be used to create unique marks. The artist Emil Nolde kept his old frayed brushes for making coarser marks. Why not use them for applying masking fluid or ink, too?*

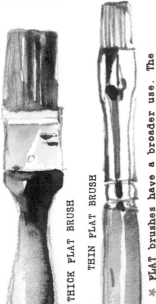

THICK FLAT BRUSH

THIN FLAT BRUSH

* FLAT brushes have a broader use. The square, chisel-edge is good for toning paper or laying one-stroke washes.

FAN BRUSH

BAMBOO BRUSH

* ORIENTAL or BAMBOO brushes are made of goat, deer or rabbit hair. Their softness lends itself to sensitive, linear drawing.

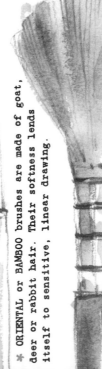

* BLENDER and FAN brushes, gently worked into wet pigment, allow two or more colours to run smoothly into each other.

# BASIC MARK-MAKING

*Viewing the perfect tradition of 'alla prima' (getting it right first time) in the Old Master drawings is one thing; perfecting it for yourself is quite another matter.*

*Effortless washes over light, accurate pencil drawings, and the sparkle of bare-paper highlights are not the only ingredients necessary for a successful sketch. The accepted modern approach to watercolour also employs unconventional forms of mark-making.*

*Spend time trying out the techniques suggested, plus any others you can think of. Do not concern yourself with depictions of things you know, but concentrate instead on making marks for their own sake.*

A BLENDED WASH OF YELLOW AND BLUE

A SIMPLE GRADATED WASH

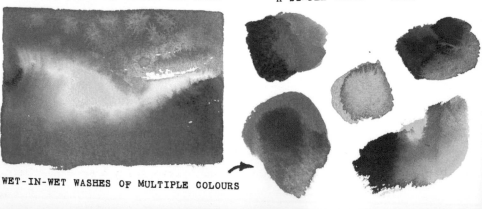

WET-IN-WET WASHES OF MULTIPLE COLOURS

**WASHES** are either laid in the same tone or change from one tone to another. Dampen the area to be painted and mix more than enough colour. By tilting your paper and quickly brushing strokes in a horizontal direction, the colour bands should run evenly into each other. Lift any excess water at the bottom using a dry brush or rag.

**STIPPLING** involves applying colour in dots, which the eye perceives as a tone.

**SCUMBLING** means simply scrubbing dryish pigment into the surface from all directions and is useful as a textured base on which to work.

\* A combination of wet-in-wet, wet-on-dry and soft gradated washes were used to attain this sensual and brooding landscape.

**DRY BRUSH RENDERING** is best for detail work. Very dry, single colour is drawn from a fine point and is particularly effective when cross-hatched in vertical, horizontal or diagonal directions.

**WET-IN-WET** works on the principle that watercolour spreads naturally over a damp surface. Using this technique you can produce glorious colour mixes onto a previous wash that is not yet dry.

**WET-ON-DRY** will form a watermarked edge with the full translucency of the colour beneath showing through. It is excellent for crisply defining a particular shape.

**LINE AND WASH** is a principal sketcher's technique. The 'bones' of a drawing can be sketched in using pen and ink and then softened into tone, to give it body. Colour may be added to enrich its blue-grey hue.

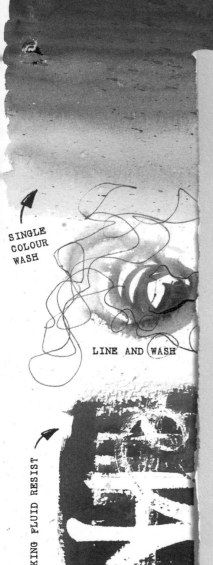

SINGLE
COLOUR
WASH

LINE AND WASH

MASKING FLUID RESIST

## OTHER TECHNIQUES

SPLATTER by flicking the bristles of an old toothbrush or coarse-haired paintbrush, but watch your clothes or passersby.

BLOTTING OFF with blotting paper or tissue is excellent in its own right and a rescue technique when mistakes need removing.

SPONGING is similar to blotting off, but you can also paint onto the paper by dabbing.

## RESISTS

WAX and OIL do not mix with water, making them a perfect combination for resists. Regardless of the density of your washes, the drawing always shows through with a bubbly texture on the surface.

MASKING FLUID is a yellowish liquid rubber that must be applied rapidly with a brush or nib. When dry, add colour and then, when this has dried out, remove the rubber seal with your finger and you are left with a masked white area. Use an old or inexpensive brush designed for the purpose, because masking fluid does damage to bristles!

MASKING TAPE is useful for defining outer edges when a regular border is needed. Washes cannot penetrate the surface where tape is applied. Always try a tester in the corner of your paper because a strongly adhesive tape can rip the surface.

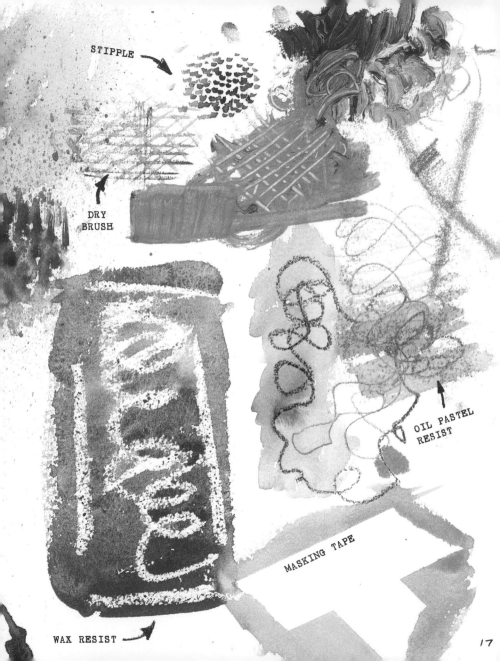

STIPPLE

DRY
BRUSH

OIL PASTEL
RESIST

MASKING TAPE

WAX RESIST

17

# OUTLINING AND DRAWING WITH A BRUSH

Begin as you intend to continue – boldly! Drawing directly onto the paper with a brush will increase your confidence and provide a good starting point for any serious sketcher. The ancient Chinese painters were practised in brush painting and their simple brush strokes reveal enviable control and teach us to view reality with sensitivity and economy.

Draw a small group of familiar objects using a medium-sized brush and single colour. Let your eye hug the contours of each object and fluidly brush them in. Try holding the brush in different ways, changing the pressure of the strokes and the dilution of the paint as you go. Do not worry about mistakes – simply sketch over the top. Redundant marks will help to define the drawing's intention as a study.

The strong lines of kitchen utensils, crockery and fruit will help you feel at home and make your first task less daunting.

# LAYING DOWN TONE

With your line drawings in place, load your brush with a single hue and add strong, unfussy washes to the objects to describe their tone. Tone defines the variable scale from white through to black, and tonal values are present in all other colours, too. By recognizing weights of tone in colour you will be able to create lively pictures that display contrast and depth.

strong colour
~e blue provides the fullest
~nge of darks and lights.

## TIP

It is a good idea to have a strong directional light source, such as a lamp or window, cast onto the objects. This will illuminate the full range of tones.

PAINTING deep washes into the
~llows between two objects and beneath
~ere shadows are cast, brings them to life.

# VARYING COMPOSITION

*It is not essential to ritually compos[e] every sketch you make, but a few basic considerations can alter the dynamic of your work. Good composition works on the principle that your picture should not be divided symmetrically. If you have divided th[e] sections unequally, with the key elements or strongest tones domina[ting] in these sections, then you've probably got it right.*

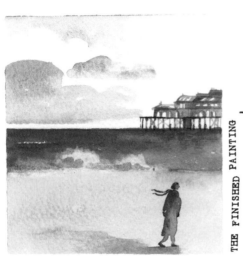

THE FINISHED PAINTING

This simple watercolour of a person on the beach demonstrates one approach to composition. There are three strong horizontal bands moving across the picture; sky, sea and sand. The regularity of the bands is broken up by the rigid pier structure, which stands on the middle band, facing into the painting. To counter this, the walker is moving in the opposite direction, trailing its shadow.

## PRACTICE

Make small thumbnail studies on a sheet in your sketchbook before attempting a more formal painting. Basic shapes, colours and tones will do - nothing too elaborate. The strengths will be obvious, so choose the best one.

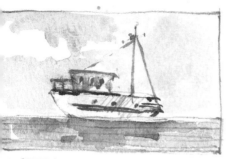

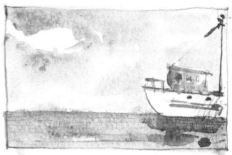

* CENTRALIZING the boat makes it a strong focus of attention, but allows little creativity.

* THE SPACE which results from the boat being moved to the edge is more attractive to the viewer's eye.

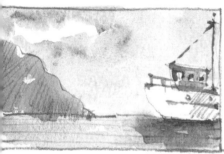

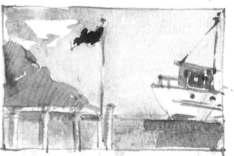

* ADDING landscape forms into the background of the composition counterbalances the boat and sets up the illusion of distance.

* FOREGROUND structures like railings help to move the viewer's eye through distances in a picture. The flag gives the picture a new dynamic.

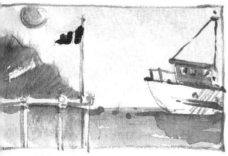

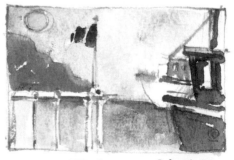

* DIVIDING the composition with such evices allows the introduction of ew objects such as the sun, while till maintaining pictorial unity.

* OVERLAPPING the new red boat on the right introduces further detail and shifts emphasis yet again in an unbalanced composition that works.

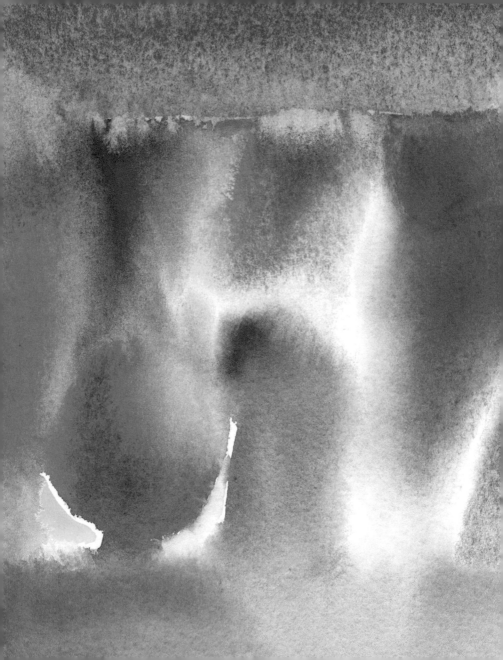

# INTRODUCING COLOUR

From the broadest, most vivid, melting sunset
to the subtlest reflections in a tiny rain
droplet, colour is vital to the function of
our planet. Every species of plant and animal has its own
unique colour characteristics, enabling it to blend into
or contrast with its native environment. There are even
tiny plants in the deserts, vividly coloured, that seem to
serve little or no function at all. They bloom for a day
and then die, and no one ever sees their beauty.
Nature is overextravagant in this way and beckons
us to reply with an appropriate reaction. We can
take our sketchbooks and paints and engage with the
wonders set before our eyes.

Oil paints display the deeper, richer hues of life, but
only watercolour can translate successfully the daily effect
of light as it alters the colours we see. The translucent
behaviour of the pigment cascading across the paper offers
us the chance to learn to see colour as it really is, and
thereby changes our understanding of colour forever.

in conditioning our emotional responses, helps define our thoughts about them.

# BASIC COLOUR

For a full range of colours, you do not have to buy the biggest box of paints. There is no doubt that it is best to start with a limited palette, from which you can mix all the colours you will need. The range and availability of today's colours would not have existed for artists such as Thomas Girtin, John Sell Cotman and J. M. W. Turner in the eighteenth and nineteenth centuries. It was not uncommon for them to lay perhaps three or four pale washes of a colour to create four or five different tones of the same from a basic palette of just three or four colours.

Your own choice of palette will evolve naturally as you progress, but here are some recommended colours, in terms of their pigment strength, purity and fastness to light.

a sunset viewed from the beach at Positano on Italy's Neapolitan Riviera was just perfect for exercising the delights of a

**✳ CADMIUM RED**
Very light-fast.
A little of this
goes a long way.

**✳ PURPLE MADDER**
Durable and a
good base for
purple hues.

**✳ CADMIUM YELLOW**
Strong orange-
based yellow for
tinting, with
good permanence.

**✳ LEMON YELLOW**
More golden and
paler than cadmium
yellow, but
equally permanent.

**✳ EMERALD GREEN**
Grainier in
consistency
and a good
mixer with
burnt sienna.

**✳ PRUSSIAN BLUE**
Not very light-
fast, but this
vivid mixer
goes well with
all colours.

**✳ FRENCH ULTRAMARINE**
Pure and durable,
with a violet
warmth. Produces
strong washes.

**✳ BURNT SIENNA**
An earth pigment
with high purity
and transparency.
Mix with cadmium
yellow to make
yellow ochre.

**✳ BURNT UMBER**
A cooler light-
fast brown,
deeper and
darker than
burnt sienna.

# MIXING COLOURS

Theories about colour are not essential reading, but they are useful in broadening your understanding and application of colour's infinite possibilities.

The French Impressionists opened the eyes of the art world to the dramatic use of 'spectral' colour (discovered by Isaac Newton in 1666), which appears when white light is passed through a prism. They also added to the scientific theories of the French chemist Michel Eugène Chevreul (1786–1889).

Red, yellow and blue are known as **PRIMARY COLOURS**. In theory it is possible to mix any colour you wish from these three colours.

## THE COLOUR WHEEL

Tertiary colours lie in between the primary and secondary ones that were mixed to create them. Secondary colours lie opposite the primary colours NOT used to create them. For example, orange (a product of red and yellow) is found opposite blue.

Mixing any two primaries creates a **SECONDARY COLOUR**. So, for instance, the combinations of red, yellow and blue will give orange, green and violet.

Secondaries mixed with primary colours neutralize the pigment into a **TERTIARY COLOUR**.

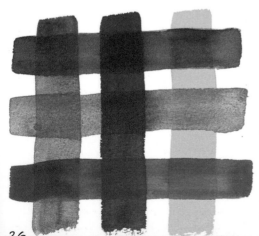

✳ CROSS-HATCHING with bands of primary and secondary colours is a neat way of looking at colour and will help to understand where you are at a glance!

*Hues from blue and red*

✳ **MAKE** up a colour catalogue of sheets you produce and store them in a handy place, where they can be readily accessed in a moment.

*Hues from blue and yellow*

✳ **EXPERIMENTAL** approaches to colour theory are the most enjoyable way to discover infinite possibilities for your own work.

✳ **SEE** how warm and cool colours interact. They can be used dull or bright, with full intensity or washed into subtlety to express the mood of your painting.

*Hues from red and yellow*

*Random wet washes to create further colours*

✳ **MIXING** the first two primary colours will always produce the third secondary.

## PRACTICE

On a fresh sheet of paper, loosely paint pairs of primary colours so that they run into each other and you discover the newly created secondary.

Cross-hatch two primary colours and a secondary and note the tertiary 'square' at the point where a primary and a secondary cross.

27

# MIXING COLOURS

*The effusive colours of the Italian city of Verona just had to be jotted down speedily as the spring evening light receded behind the characteristic skyline. Once the basic architectural shapes had been outlined with a fountain pen,*

ULTRAMARINE
BLUE

CADMIUM YELLOW

CADMIUM RED

WITH just three basic palette colours the Verona study was brushed into existence. Practising the principles of colour theory is the surest way of gaining the necessary knowledge to be able to sit before your subject and make relevant choices.

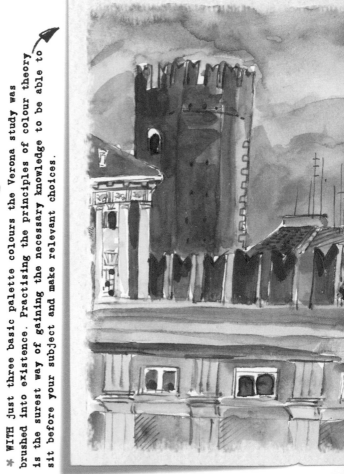

washes of cadmium red, cadmium yellow and French ultramarine were laid onto the sketchbook page, producing the necessary secondary and tertiary ranges. Where the blue-grey of the line was dissolved into the colour, its subtle contrast helped enhance the gentle glow of the picture.

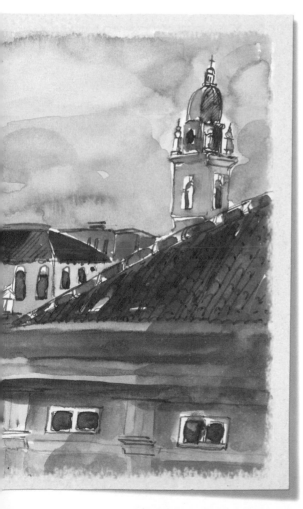

YELLOW AND
BLUE MAKES OCHRE

CADMIUM
RED

RED AND
YELLOW MAKES
PINKY ORANGE

ORANGE

ADDING BLUE
PRODUCES
WARM VIOLET

PINK AND
YELLOW

## COMPLEMENTARY COLOURS

Complementary colurs sit opposite
each other on the colour wheel and
create maximum excitement in their
reaction to each other. Their
discords are so strong that they
work more powerfully together than
apart. Violet is the complement of
yellow, red the complement of green
and blue the complement of orange.
Unequal amounts of these colours
can set up interesting imbalances
and by deliberately exploiting such
imbalances, the artist can make or
break a composition. Past masters
like Paul Klee set up complex
rhythms to entice the viewer into
his riotous, technicolour concert.

# COMPLEMENTARY COLOURS

Using colour complements can release power and energy into your work. August Macke's sketching trips to Tunisia, North Africa, in 1914 totally refreshed his artistic vision. The rich Moorish colours set against the hot, sunny climate brought about a profound change in his working methods and choice of palette, and he began to express himself more directly and with greater luminosity. Returning to familiar subjects he brought this newfound colour sense with him and applied bold complementary hues with great force and authority. Artists who take such a step rarely go back to their old methods of practice and Macke's example reinforces the need for every practitioner to keep developing their colour sense.

✳ GUARDING the land as a territorial giant poised and ready for action – Marc's Ibex has extraordinary command when set against complementary colours.

'Ibex' FRANZ MARC (1880–1916)

Franz Marc, a friend of Macke, introduced complementary colours into his compositions to help depict the strength of his personal spiritual beliefs, as revealed through the unity and rhythms of the natural world.

His sense of structure, tone and proportion was extremely acute and he arranged the elements of his pictures to create a unique semi-abstract expression of time and place.

# IMPACT WITH COLOUR

*Young children paint naturally and with great impact. With no inhibitions, they attack the paper – dragging, scratching and firing the brush out in every direction from a wet explosive centre. The colours naturally run into one another, resulting in a simple, yet powerful expression of self. Never lose sight of childhood, for it is invaluable in your development as a watercolour artist. From time to time, just release the reins of a self-conscious mind and simply let yourself be. Escaping from the rules which dictate much of our adult thinking can be refreshingly liberating.*

※ YOUNG toddlers with a less developed attention span bash into the paper with little concern for the end result as Tilly's picture boldly testifies!

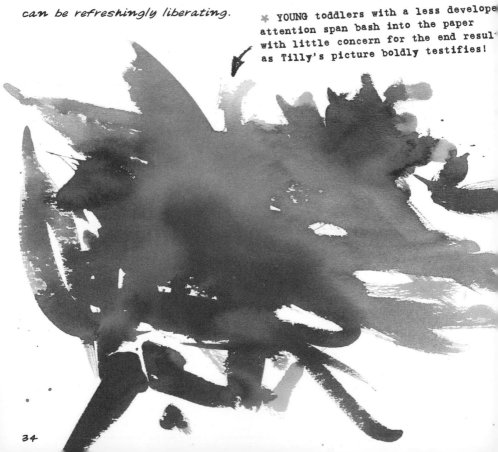

34

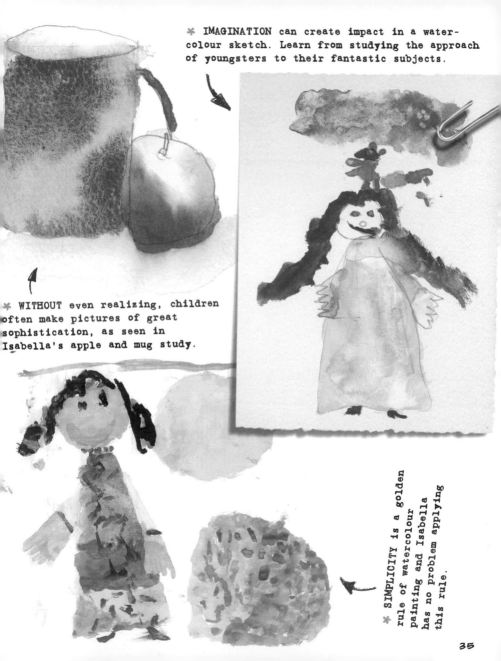

✻ IMAGINATION can create impact in a water-colour sketch. Learn from studying the approach of youngsters to their fantastic subjects.

✻ WITHOUT even realizing, children often make pictures of great sophistication, as seen in Isabella's apple and mug study.

✻ SIMPLICITY is a golden rule of watercolour painting and Isabella has no problem applying this rule.

35

# IMPACT WITH COLOUR

The force of 'impact' can be illustrated in many ways. A warehouse fire by a river completely altered the shape of the landscape for a time and had a strong impact on the composition of this study. Thick, acrid smoke engulfed the scene, dominating the whole area. The contrasts between the prevailing dark grey washes to the left, as they bleed off the page, and the small, vibrant red boats anchoring the composition give it impact.

Unusual lighting also has a strong effect on pictorial elements. The reflected light of the moon, blurrily breaking through broken clouds and backlighting others, adds drama to the study. The greatest impact is seen where the soft yellowy-blue stains of the sky meet the hard-edge intensity of the land.

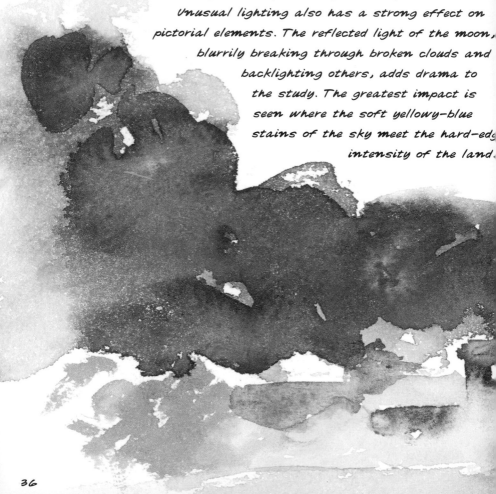

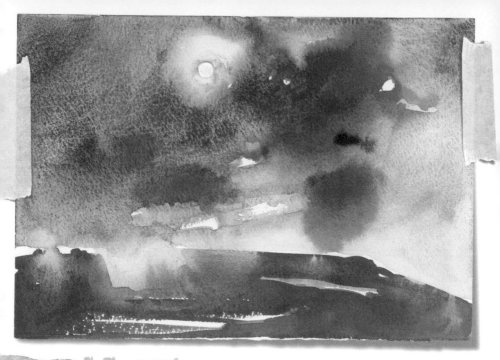

✳ **WHEN** attempting a sketch like this, try not to get too preoccupied with the details. Its impact relies on the large fresh areas working together.

✳ **CAPTURING** the excitement of a fire or other spectacular event is only possible if you are fully prepared for it. The probability of witnessing such events is slim, but carrying your watercolour box and a small pocket sketch-book with you when out and about provides the best chance.

# SUBTLETY AND COLOUR

*It is through his sketchbooks that Turner can be confirmed as a master of subtlety and colour. Termed 'colour beginnings', sheets stained with apparently random pigment were adapted by means of his creative skill into landscapes, seascapes or sunsets. Using carefree brushwork and liquid washes, Turner added mystery, atmosphere and light to the scenes before him. He was clearly ahead of his time, and his extraordinary talent has not been surpassed. We can learn tremendous amounts about the subtle use of watercolour by studying his huge legacy of watercolour studies and sketchbooks. With the benefit of good colour reproductions, you can study Turner's application of washes. In many of his land and seascapes executed on calm days the traditional method of overlaying pale translucent washes one on top of the other can be clearly observed. Use the work of master watercolourists as inspiration, their processes as a silent tutor.*

Subtle painting requires a minimal palette and the very lightest strokes of the brush.

✻ THINK carefully before laying down your composition on the page. Take a few good minutes to evaluate the subtleties present before you. Make sensitive practice notes on a separate sheet.

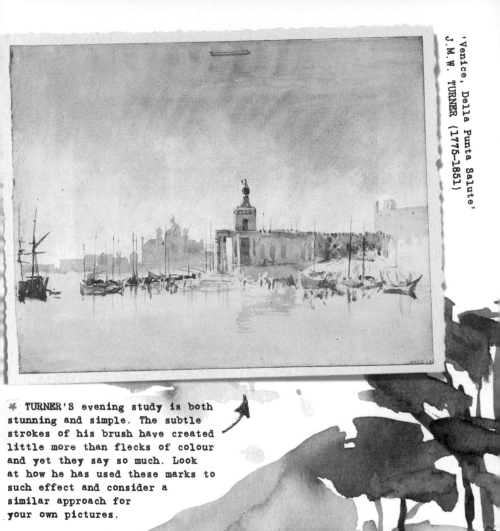

✳ TURNER'S evening study is both
stunning and simple. The subtle
strokes of his brush have created
little more than flecks of colour
and yet they say so much. Look
at how he has used these marks to
such effect and consider a
similar approach for
your own pictures.

# SUBTLETY AND COLOUR

On a serene day, take yourself off to a quiet place, perhaps by a lake or in a wide, rolling meadow, and gently lay down wet-in-wet or wet-on-dry washes, being careful at all times not to put in too much detail. Let the brush describe the contours and forms as it sloshes over the paper in front of you

Use no more than three colours, and try a sequence of studies of the same scene. Make sure that the first is purely 'monochrome' – that is, one hue only. Do not be too precious about the outcome and do not add any detail after the event. May the spirit of Turner go with you.

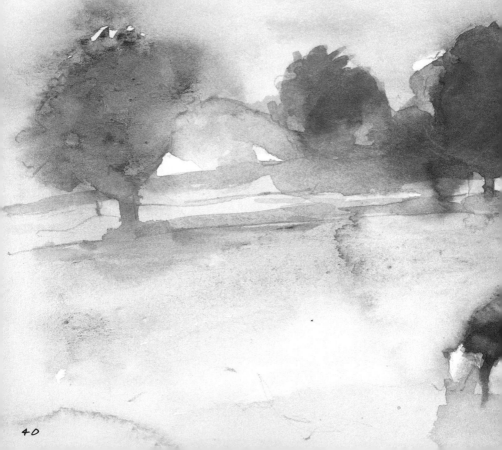

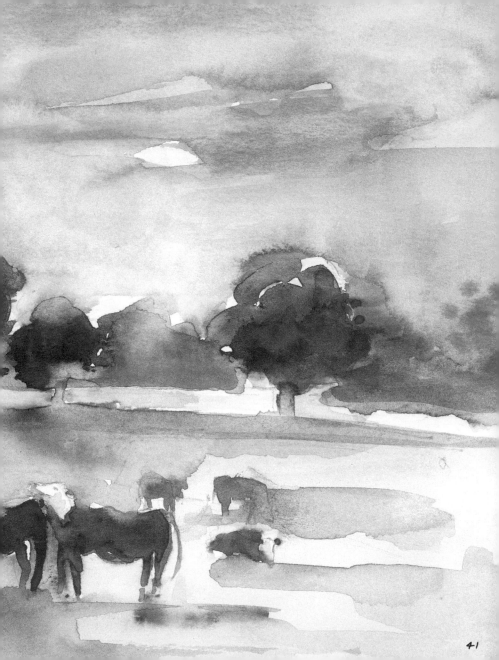

41

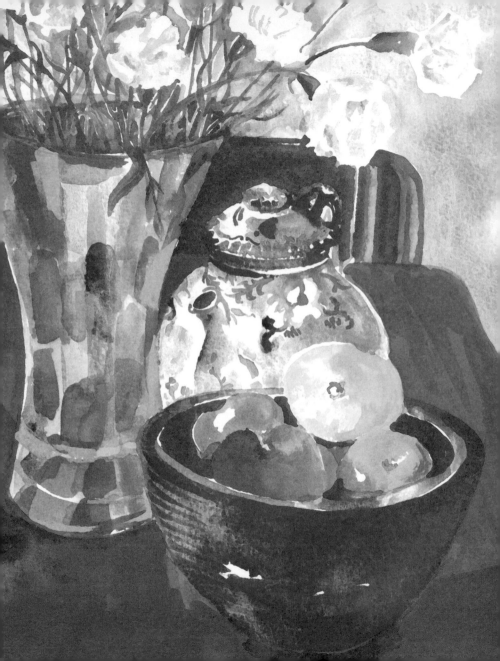

# WORKING INDOORS

Build up your confidence in familiar surroundings and explore with new visual intensity the very dwelling you have probably come to take for granted: home.

The interior world makes an excellent topic for watercolour study. As you look around a room, you will notice interiors within interiors, natural compositions framed within windows and small spaces between furniture and objects that have strong painting possibilities. Look at chairs, tables, plants, domestic objects and artifacts: all have structure, shape, colour, pattern and texture, and can be observed from numerous viewpoints. Consider, too, the important role of lighting: natural by day, artificial by night.

Children and animals have an innate curiosity in the domestic setting, hiding in cupboards, stretching out on carpets or spying down stairwells. Such positions give a refreshing outlook on what might otherwise be brushed aside as a mundane area of our existence.

Selecting objects that have similar size and help
They all have strong shape and colours which help enormously.

# FAMILIAR OBJECTS

The domestic clutter of kitchen utensils, jugs, teapots and even dishes drying on a rack gives a good starting point for studying the familiar. Indeed, a whole art movement, 'The Kitchen Sink School', was founded in Britain on this theme in the 1950s. Look at the relational values of the objects when observed collectively – rough against smooth, large against small, patterned against plain, soft against hard, and so on. There is so much to learn through drawing even the simplest of objects, such as an orange, whose pitted skin and juicy segments offer much to explore by way of line, colour, form and texture.

* SHINY things give your paintings an extra lift and the device of leaving white paper showing produces convincing highlights.

* SPRINKLING household salt onto specific areas of your picture gives a mottled texture. When dry, simply shake the grains away and all will be revealed. The skin of the courgette was created by this method.

Unusual choices of fruit such as the persimmon make life a little more interesting, and may lead you to select equally unusual accompaniments.

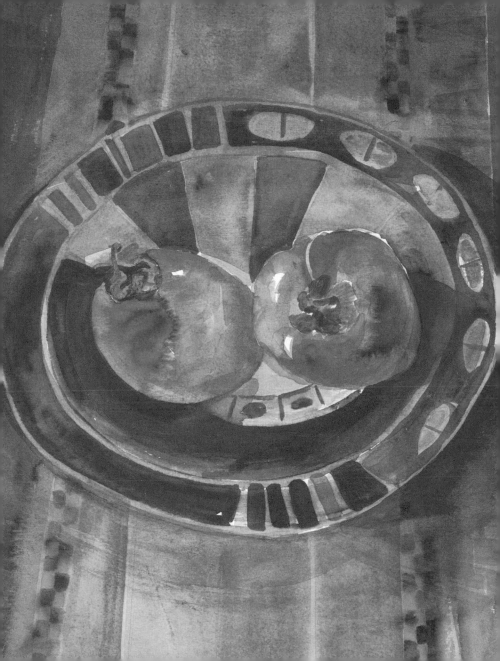

# ENCLOSED WORLDS

*Acquaint yourself with the notion of working within confined spaces by trying this simple exercise. Take a small box or jar and pack it with objects found around the house, such as string, fabric, pieces of cutlery, scrunched bags and toothpaste tubes. However they rest inside the container, consider it to be your composition for a watercolour. Pay attention to the way each object sits in relation to its neighbour, and carefully pencil in the contours of their shapes.*

*Then, with a limited palette of colours, paint in the different objects using a variety of techniques to describe their form and texture. The darker gaps in between will help you to understand how objects take on a greater feeling of depth inside an enclosed space.*

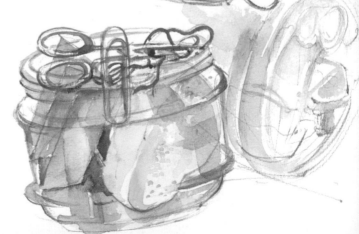

* RUBBER bands, paper clips and other simple ephemera are so easily discarded, with no further consideration of their potential. There is picture possibility in everything. Start collecting now!

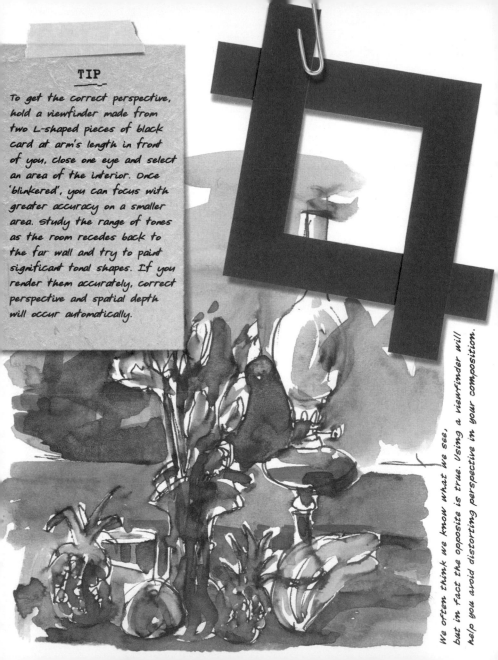

We often think we know what we see, but in fact the opposite is true. Using a viewfinder will help you avoid distorting perspective in your composition.

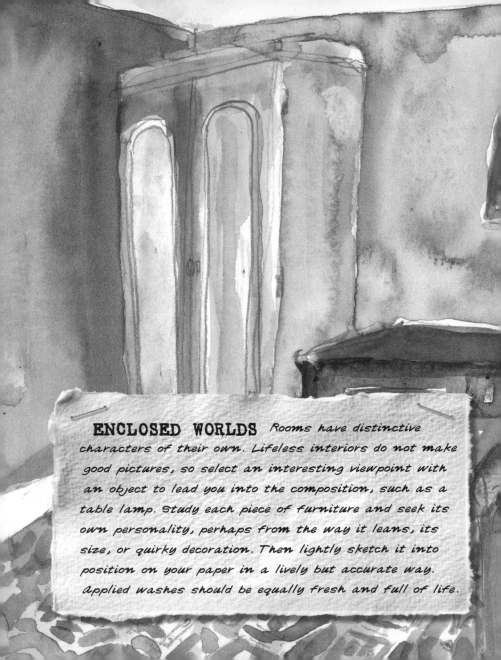

**ENCLOSED WORLDS** *Rooms have distinctive characters of their own. Lifeless interiors do not make good pictures, so select an interesting viewpoint with an object to lead you into the composition, such as a table lamp. Study each piece of furniture and seek its own personality, perhaps from the way it leans, its size, or quirky decoration. Then lightly sketch it into position on your paper in a lively but accurate way. Applied washes should be equally fresh and full of life.*

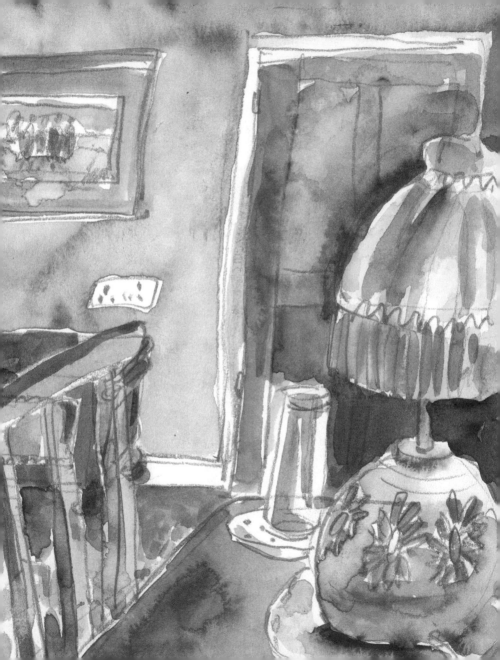

# LOOKING OUT FROM WITHIN FOUR WALLS

Curtains waft in the gentle breeze as you nudge the window open and greet the new sensations of another waking day. The theme of window spaces recurs throughout the history of art. It is the divider of two contrasting worlds, whose spaces, colours, climates and activities are often very different. The natural viewfinder created by the frame of the window and its vista beyond have always held a huge attraction for painters. They often see it as a symbol of escape and freedom from themselves, but with a sense of security in the familiar. Such images will remain for as long as artists choose to express personal thought and feeling.

✳ PEERING through to the yellow room symbolizes the yearning to be present in a brighter, warmer place. The heavy use of wax resist adds to the metaphysical quality of the study and the passage of time is just visible in the presence of a clock in the top right-hand corner.

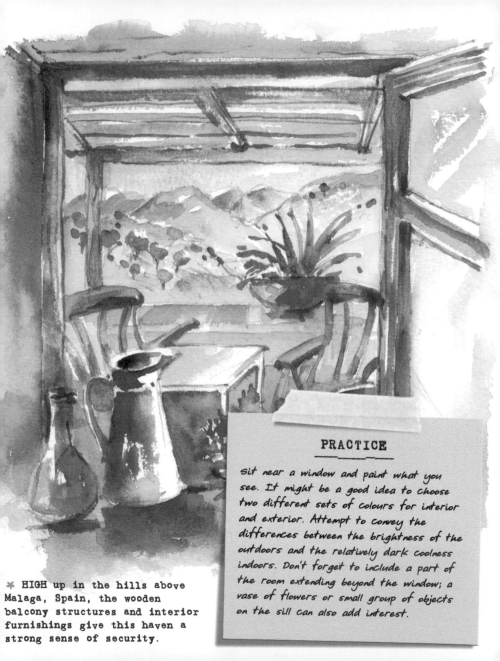

**PRACTICE**

Sit near a window and paint what you see. It might be a good idea to choose two different sets of colours for interior and exterior. Attempt to convey the differences between the brightness of the outdoors and the relatively dark coolness indoors. Don't forget to include a part of the room extending beyond the window; a vase of flowers or small group of objects on the sill can also add interest.

✳ HIGH up in the hills above Malaga, Spain, the wooden balcony structures and interior furnishings give this haven a strong sense of security.

# PAINTING UNDER ARTIFICIAL LIGHT

If you have ever tried painting a picture by the light of a table lamp, and then checked it in the stark daylight, you probably got a nasty shock. The pure colours you thought you used would all have been tinged with the same orangey-yellow shade. This is because tungsten filament bulbs (those we use in our homes) give off a soft yellow glow.

Why not use this to your advantage and intentionally make a watercolour primarily using the warmer shades in your box? Wash a 'ground' of pale yellow over the paper before you begin, so that every mark of every colour you use will reflect the glow beneath. For a brighter finish, wash yellow over selected areas only — for example, where the light catches a face or a shiny object, such as a drinking glass.

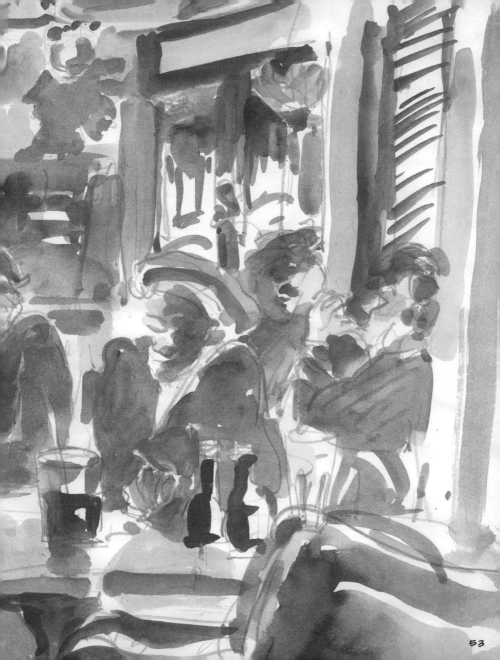

53

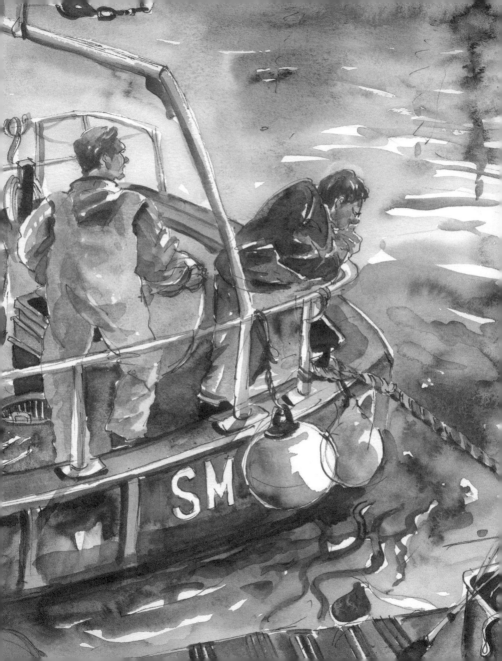

# WORKING OUTDOORS

Come rain, come shine, the place to toughen up those artistic muscles is beyond the front door, where the weather can be unpredictable, the light changes constantly and passersby look over your shoulder. However, learning to work quickly and under pressure makes for an accomplished artist, and measuring your relative progress against simpler tasks that you once found difficult can be very encouraging. Painting outdoors is incredibly engaging and, engrossed in recording the impressions that catch your eye, you will find that time passes you by. Townscapes offer the buzz of life, and land and seascape offer a chance to commune with nature. Both result in a new sense of vitality in your sketchbook.

All sorts of things can happen when you are out there, and some are beyond your control, but add a new quality to your work. These happy accidents should be given the same merit as conventional techniques, and it is good to consider that you partnered nature when they were produced.

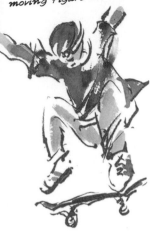

Skaters make perfect subjects for drawing the moving figure on location.

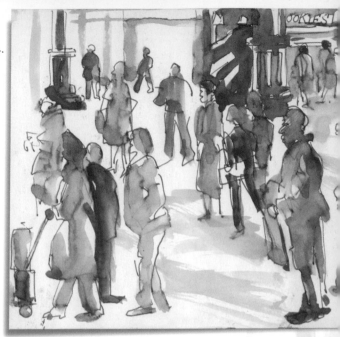

# SKETCHING ON LOCATION

If you are in a busy public place, start with a drink at the nearest café to help acclimate yourself to your new surroundings. Painting on location is not just about the visual sense. Listen to the sound of shuffling feet, the garbled murmur of conversations, and 'feel' the atmosphere: these intrinsic qualities may influence your choice of brush size, tools and colour range. Musicians are especially good as a subject, because they provide an artistic accompaniment and can help you establish rhythm in the sketches. Skateboarders have their own attitude and culture, and rarely pull the trick off first time – just when you think you've got a skater in your sights, it's all over.

Keep your expectations low, gradually increasing them in line with your proficiency. Take materials that are broad and rapid enough for the job in hand, and which you feel comfortably in control of. Above all, be kind to yourself: this takes many years to master.

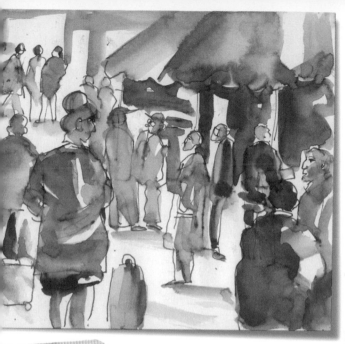

✳ CAPTURE the bustle of the station concourse in a relatively short space of time. A fineliner or fountain pen provides strong figurative shapes which bleed into the watercolour when it is added. Never get overfussy with the subject.

✳ A sharpened stick provided the basic tool for this study of jazz musicians. The improvised marks that were made matched the music!

## TIP

Where people are your subject, outlining broadly with a pen or brush and then filling in with a fluid wash will enable you to catch the essence of the movement. Fussy concern with detail will achieve very little.

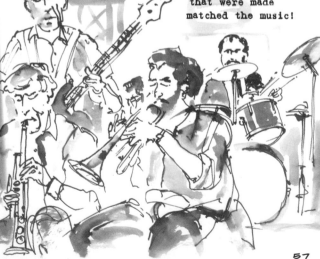

57

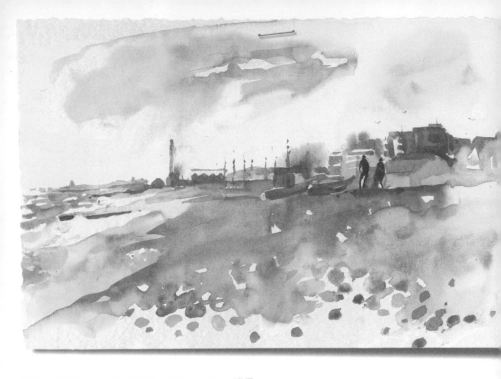

# WORKING WITH SUNLIGHT
Sun is seasonal, affecting colour and light dramatically. Warm colours in a cool setting create a startling effect. The warm browns of leaves set against the blue-green passages of a receding sky and trees complement each other. The sun is low in the sky during autumn, and reflecting objects such as buildings are a brighter white. The best source of this whiteness is bare, unstained paper. Summer sun throws up the vibrancy of pure colour, and each pigment on the palette stimulates the eye. Buildings are more reflective of the hues found in their immediate vicinity, and appear softer than in autumn. Shadows are richer and denser in summer sun and, by using warmer blue and violet shades against orange and yellow, the 'glow' is at its most intense.

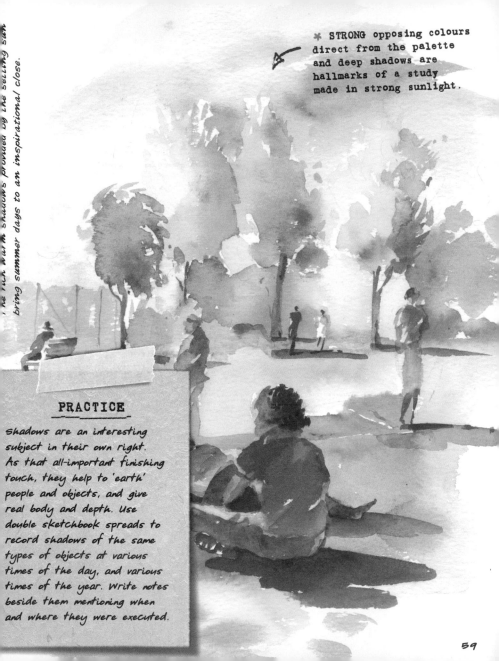

The rich warm shadows provided by the setting sun bring summer days to an inspirational close.

**\* STRONG opposing colours direct from the palette and deep shadows are hallmarks of a study made in strong sunlight.**

## PRACTICE

Shadows are an interesting subject in their own right. As that all-important finishing touch, they help to 'earth' people and objects, and give real body and depth. Use double sketchbook spreads to record shadows of the same types of objects at various times of the day, and various times of the year. Write notes beside them mentioning when and where they were executed.

# WORKING WITH SUNLIGHT

Melancholic, reflective and dreamy are all fair descriptions of the university city of Cambridge, England, at sundown in the winter. For this simple study, two pale washes of cobalt blue and lemon yellow were blended as an underpainting for subsequent washes. The green of the common in the foreground was dropped wet-in-wet onto a mix of cobalt blue and purple madder and left to bleed. The buildings and trees on the horizon were painted with a little added green and burnt umber, in one broad sweep, and no further detail was added. The moving clouds were saved until last and were placed strategically to give the sketch good compositional balance.

As is so often the case, this scene was stumbled on during a leisurely afternoon stroll. The context of light with silhouetted shapes, the drifting rhythms of the forming clouds and the extraordinary colour combinations that illuminated the entire city provided the serendipitous subject for a watercolour painting. Such times are rare, but always be ready when working with sunlight to embrace an experience that will boost levels of inspiration and confidence!

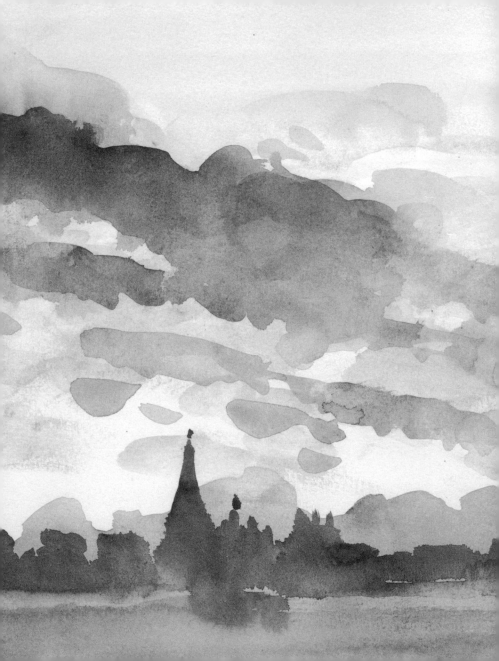

# WORKING WITH CLOUDS

*'I can hardly write for looking at the silvery clouds; how I sigh for that peace to paint them which this world cannot give, to me at least', wrote John Constable in his correspondence of August 1833, in reference to his preoccupation with recording the clouds at a given moment in time. Constable filled endless sketchbooks with every sky imaginable, using watercolour,*

'Old Sarum' JOHN CONSTABLE (1776–1837)

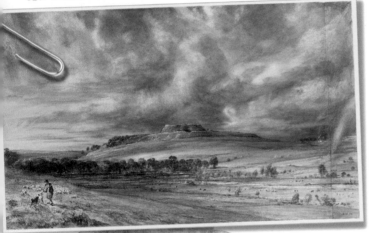

*and no other medium has surpassed its ability to replicate water vapour so closely.*

*If you enjoy watching storm clouds gathering over an open field, or hunt faces as they form in cumulus clouds, then dedicate some time to this worthwhile subject.*

✳ HALO effects, as seen when the bright sun shines through a veil of cloud, are most effectively created when the bare white of the paper butts up against the deep stain of sky.

*The same cloud formations are never seen twice. Become more aware of the infinite combinations which enclose us all on a daily basis.*

✳ **EXPERIMENT** with
wet-in-wet techniques to create
the soft, covering clouds found
at high altitude.

✳ **WISPY** cirrus clouds
are best replicated using
dry-brush hatching.

✳ **DRAMATIC** rainy skies occur
with ease when sprinkled salt is
allowed to absorb wet pigment.

✳ **STORM** clouds stack high as the
rain is forced down and warmer air
rises to form new lighter clouds.

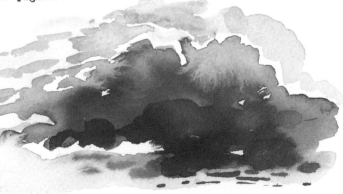

✳ **SUNSETS**
provide the most
vivid array of
surprising colour
combinations. Make
note of such
combinations and
never be afraid to
use them!

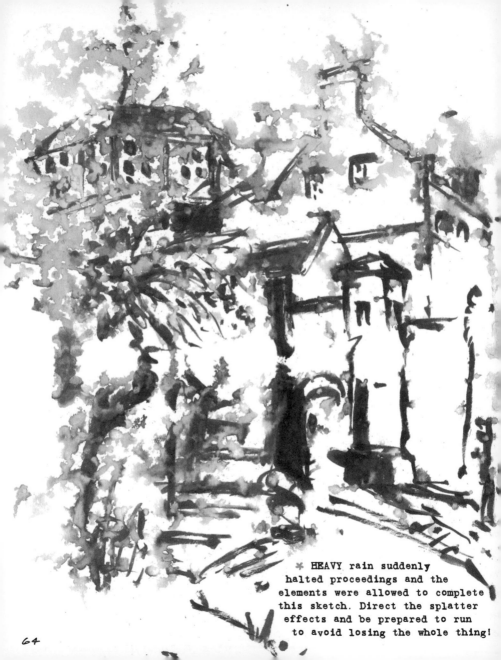

* **HEAVY** rain suddenly
halted proceedings and the
elements were allowed to complete
this sketch. Direct the splatter
effects and be prepared to run
to avoid losing the whole thing!

64

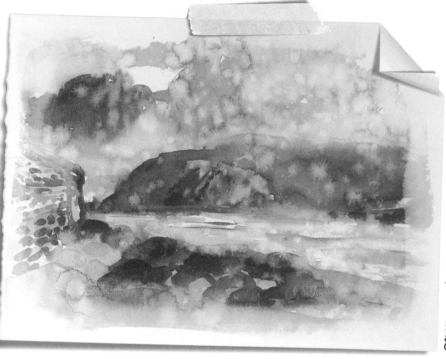

Stronger rain spots make an instant record of the weather, and when dry capture the moment forever.

# WORKING WITH RAIN

Fine drizzle, medium showers, sleet and even snow create the most exciting effects on paper – all you need to know is when to take shelter or risk losing it all. If you have already painted a scene and rain begins, the sharp edges dissolve into wet, mottled stains that strangely retain enough information for the eye to decipher them. Dropping fresh pigment onto a rain-soaked sheet of paper is like wet-in-wet on tap!

## TIP

Prestretch paper onto a board by taping it down with adhesive tape, having first soaked it in water, then allow it to dry naturally. When the taped paper is next used, it should not warp.

Sketchbook pages will warp, reaffirming their use as a recording document, but take care not to close the book fully until all the leaves are dry.

# EDITING AND SELECTING INFORMATION

It is the artist's task to learn to direct the eye, with control, to the place he or she wants it to go. Having an idea of what you want to paint, and the position from which you would like to paint it, is a good guide to editing. But how much of the subject should be included? Leaving out part of a building or car can direct the viewer to the place of greatest importance. Empty white space is an effective device that allows the eye to travel to a more relevant part of the composition. The 'vignetted' shape created by this unfilled space nudges the key elements into prominence and gives the overall picture a more exciting look.

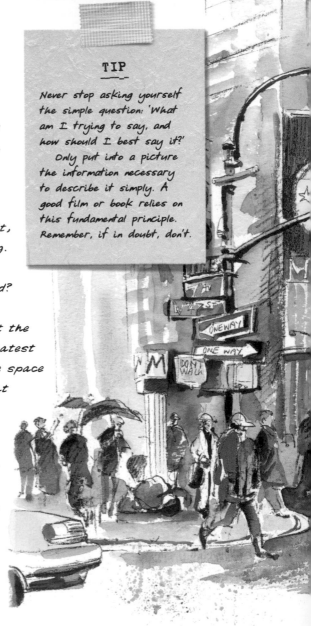

## TIP

Never stop asking yourself the simple question: 'What am I trying to say, and how should I best say it?'

Only put into a picture the information necessary to describe it simply. A good film or book relies on this fundamental principle. Remember, if in doubt, don't.

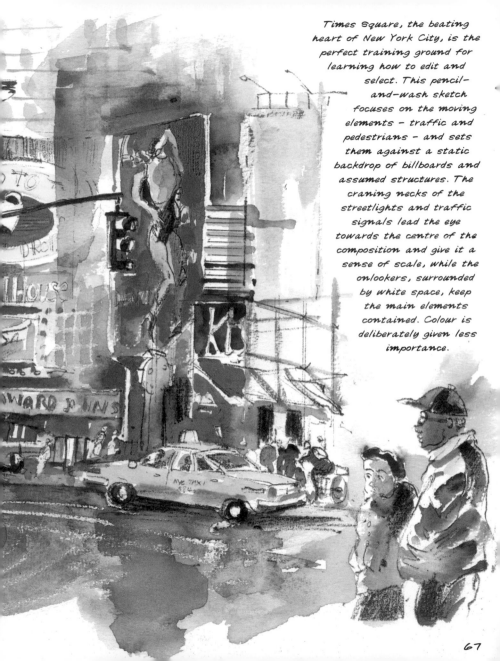

Times Square, the beating heart of New York City, is the perfect training ground for learning how to edit and select. This pencil-and-wash sketch focuses on the moving elements – traffic and pedestrians – and sets them against a static backdrop of billboards and assumed structures. The craning necks of the streetlights and traffic signals lead the eye towards the centre of the composition and give it a sense of scale, while the onlookers, surrounded by white space, keep the main elements contained. Colour is deliberately given less importance.

# USING PHOTOGRAPHY AS REFERENCE

Photography is a distinctive art form in its own right. As a method of recording facts in detail, it is second to none, but if you try to copy a photograph outright, the result will almost certainly be stilted and dull. The chemical colours of processed film are very different from the pure pigments of watercolour, and the mechanical camera image cannot produce emotive human strokes with limited selection or limited palette of chosen hues.

For recording 'snapshots' of life that occur in the blink of an eye, however, the camera is an excellent reference tool. Try to take a few different shots of the same scene from various angles and viewpoints, as you may wish to compose a studio painting with elements gleaned from a number of photos. If you wish to use a photograph to obtain an accurate outline, then you can either draw a

✳ THIS gateway in Gujarat, India, was painted later using the photo above. The colours and composition were altered where the print had failed to capture the true feeling of place.

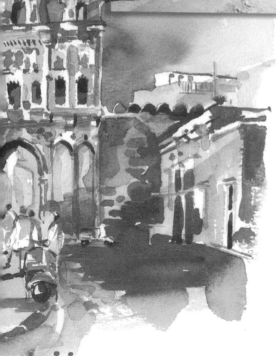

squared grid onto the print
and copy the shapes you
see onto another gridded
sheet of paper, or simply
trace over the image using
tracing paper. A specially
designed lightbox is also
an excellent way of
transferring information
from photographs or
photocopies. If you have
access to a digital camera
or camcorder, there is even
more room for experimen-
tation with these methods.

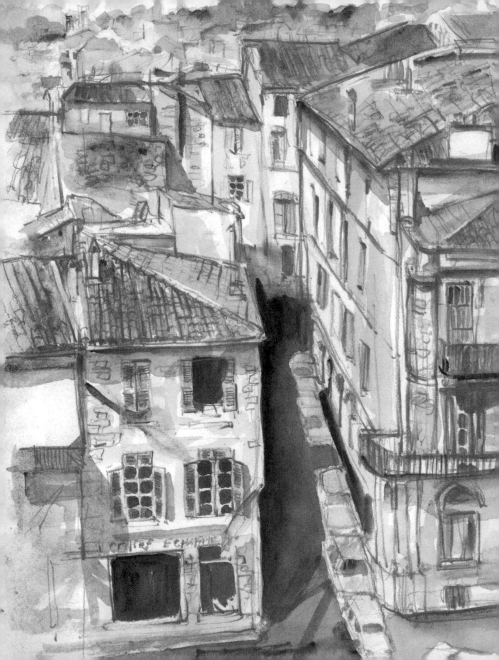

# SKETCHING BUILDINGS

Many artists express a strong desire to get out and paint landscapes. For a city dweller, this can mean a considerable drive before grey concrete ends and green fields begin. The splendour of the natural world makes it an obvious first choice, but have you ever considered the beauty of our manmade habitat? Climate, location, cultural distinctions and local materials all have a significant bearing on how we create the environments in which we live. Buildings provide refuge and a place to make our mark as individuals. The different styles of buildings reflect trends in society, which soon become history, and technological advances have resulted in a world legacy of eclectic structures.

From the mud hut to the majestic palace, there is something for everyone to admire, understand and paint. By exploring towns and cities with an open, inquiring mind, you will notice lots of things that are missed by most people.

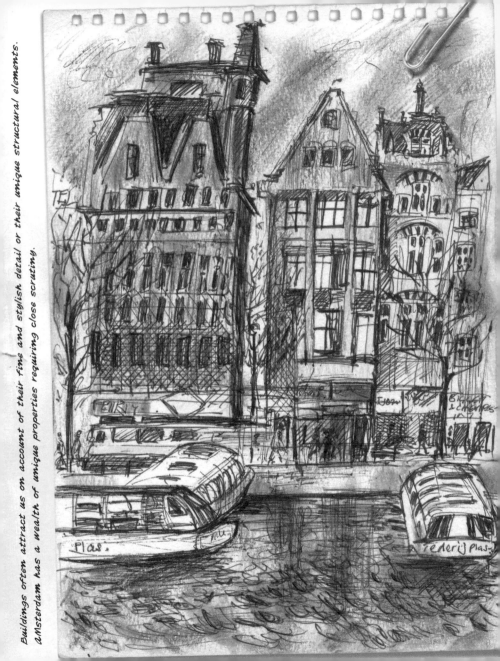

Buildings often attract us on account of their fine and stylish detail or their unique structural elements. Amsterdam has a wealth of unique properties requiring close scrutiny.

# PLACING KEY ELEMENTS

Putting every detail into an architectural study is certain to overdo it. Decide what is most important and choose a suitably interesting viewpoint. Plot on the paper the overall shape and proportions of the building, ensuring that it sits with good balance on the page. Be confident with your line, so that it draws out the solid, underlying structure, and then place the lighter features such as windows, cornices and door arches. Finally, drop fresh colour washes onto the building, mindful of any shadows cast in the recesses by strong directional light. These darker washes will enhance the solidity of buildings, sharpen the detail and increase the three-dimensional effect.

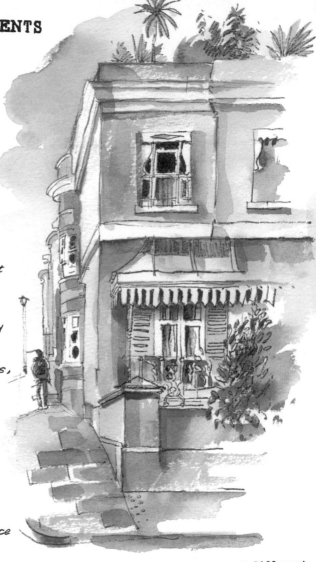

❋ ARCHITECTURAL styles demand different approaches to placing key elements. This classic 'Regency' home has clean lines and symmetrical balance.

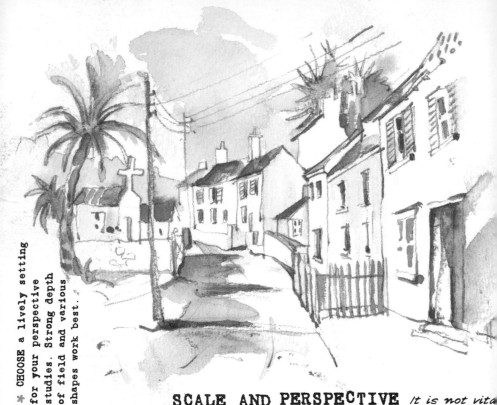

* CHOOSE a lively setting for your perspective studies. Strong depth of field and various shapes work best.

## SCALE AND PERSPECTIVE

*It is not vital to have a full knowledge of perspective, but a basic understanding will help you solve the visual problems that occur when rendering buildings. Perspective is the art of making buildings and objects in space decrease correctly in size as they recede into the distance. The proportions and distance between them should appear the same in a sketch as in reality.*

*Looking at a building from the side, we see it in perspective. The lines we know to be horizontal and vertical (planes) converge on the 'vanishing point', which always sits on an imaginary line known as the horizon. The horizon line is most clearly observed on flat land or a sea, where the ground and sky meet, and is always viewed from eye level.*

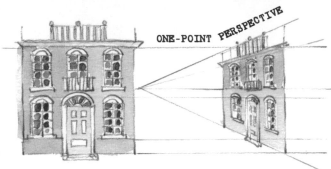

ONE-POINT PERSPECTIVE

ONE-POINT PERSPECTIVE

* **ONE-POINT** perspective is when all windows, doors and streetlights _follow_ the path of horizontal lines converging on a single vanishing point. All horizontal lines above eye level will slope DOWNWARDS and all those below will slope UPWARDS to meet at eye level.

**TWO-POINT** perspective introduces two separate vanishing points when a building is visible from two sides. Both converge on the same horizon, but not necessarily at the same distances.

TWO-POINT PERSPECTIVE

_Double check all angles of a subject; they are often far steeper than they appear to the eye._

---

**TIP**

To get the angles of perspective correct, assess the shapes present in the building. For example, a roof sloping off towards the vanishing point may be viewed as an acute triangle. Study it carefully and then lightly sketch it in pencil or ink. Draw over any mistakes; it is better to work on a corrected picture than one that looks perfect but is wrong.

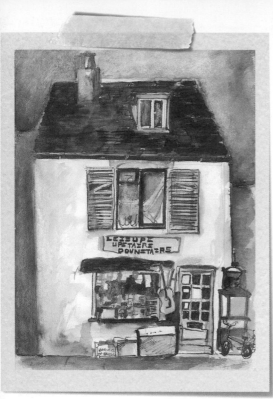

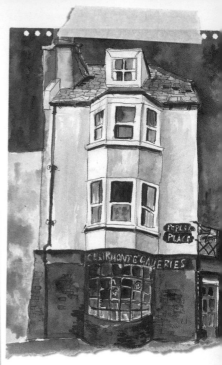

# BUILDINGS AS PORTRAITS *In one sense a portrait is a likeness of a person, but just look at a Rembrandt self-portrait and you are led by the artist beneath the skin into an*

*utterly convincing painting of someone you feel you know. It is the same for buildings and places that we visit and befriend, and yet often the emphasis is placed on architectural accuracy and seldom on likeness and character. Different aspects should be considered when portraying buildings – for example, it may be that what they do is more important than what they are; or perhaps it is only necessary to include the exaggerated features that characterize that building (caricature).*

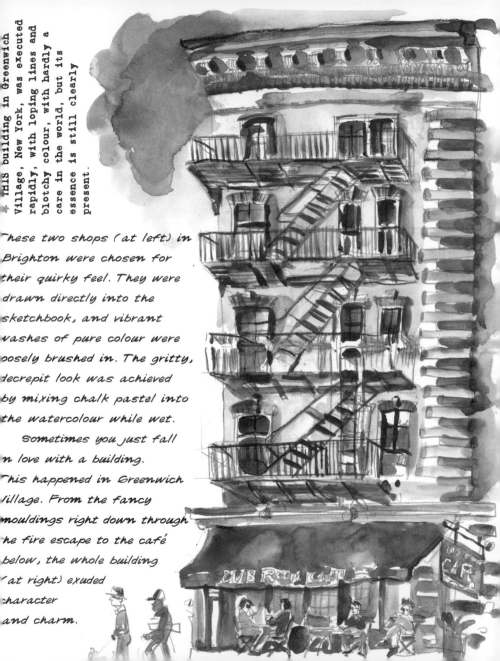

THIS building in Greenwich Village, New York, was executed rapidly, with loping lines and blotchy colour, with hardly a care in the world, but its essence is still clearly present.

These two shops (at left) in Brighton were chosen for their quirky feel. They were drawn directly into the sketchbook, and vibrant washes of pure colour were loosely brushed in. The gritty, decrepit look was achieved by mixing chalk pastel into the watercolour while wet.

Sometimes you just fall in love with a building. This happened in Greenwich Village. From the fancy mouldings right down through the fire escape to the café below, the whole building (at right) exuded character and charm.

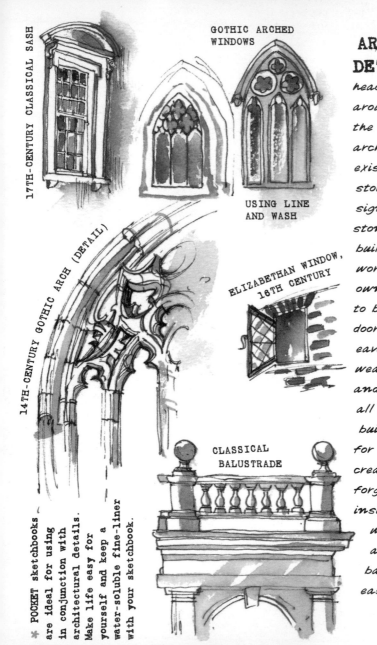

17TH-CENTURY CLASSICAL SASH

GOTHIC ARCHED WINDOWS

USING LINE AND WASH

14TH-CENTURY GOTHIC ARCH (DETAIL)

ELIZABETHAN WINDOW, 16TH CENTURY

CLASSICAL BALUSTRADE

**ARCHITECTURAL DETAIL** Keep your head up when walking around town. Some of the most fascinating architectural details exist above the first storey! Carved signatures of stonemasons and builders are small works of art in their own right and ought to be noted. Windows, doors, arches, ledges, eaves, brick patterns weatherboarding and chimney stacks all provide the perfect building materials for your own creations. Don't forget to take a look inside buildings, where such gems as ornamental banister rails can easily be overlooked.

* POCKET sketchbooks are ideal for using in conjunction with architectural details. Make life easy for yourself and keep a water-soluble fine-liner with your sketchbook.

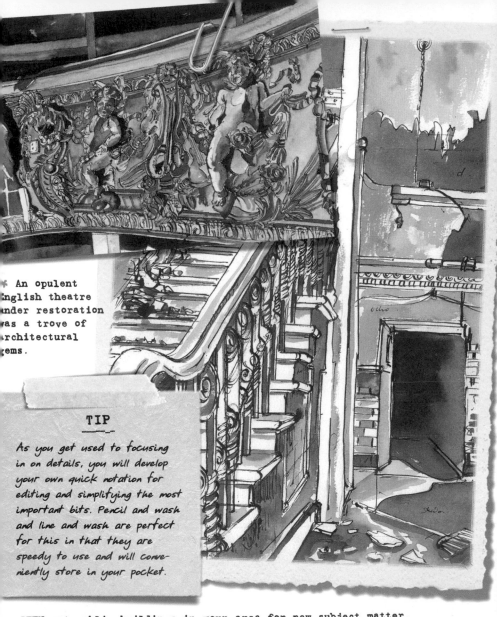

* An opulent
English theatre
under restoration
was a trove of
architectural
gems.

## TIP

As you get used to focusing
in on details, you will develop
your own quick notation for
editing and simplifying the most
important bits. Pencil and wash
and line and wash are perfect
for this in that they are
speedy to use and will conve-
niently store in your pocket.

* SEEK out public buildings in your area for new subject matter.
Chances are you have passed by many times without realizing what lies within!

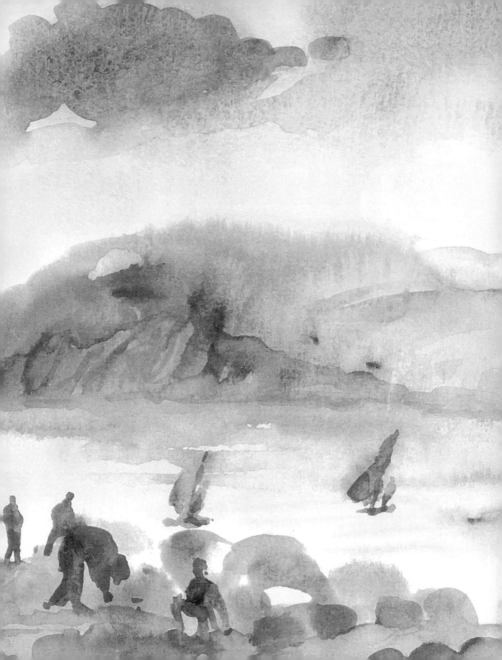

# MOVING LIFE

Life doesn't stop and it certainly will not keep still so that we can sit down comfortably and paint it. All around us, natural and manmade objects are on the move, and even a solid rock or building gives an impression of movement when the changing light of the day plays across its surface.

So the challenge presents itself daily, in every walk of life, with every blink of every eye: there is always something for us to observe and paint. The portability and convenience of watercolour as a medium cannot be underestimated. With such a quick-mixing, quick-drying, water-soluble material, we have everything necessary on hand to complete the task of recording moving life.

Like so many of life's challenges it will present you with a great deal of food for thought, and just as many problems to solve, but the sheer joy of being able to capture the moment is an artistic skill that is well worth developing.

# MOVING TARGETS

It takes around thirty seconds for shoppers on a moving escalator to reach the next level. Thirty seconds is about the minimum time required to jot down the essence of their natural stance with a controlled, freehand pencil line. Another thirty seconds can then be taken to brush in the colourful clothing of another set of shoppers on top of the original pencil outline. The last thirty seconds are employed in tidying up and finishing off the sketch, and there you have it – a record of life in one-and-a-half minutes!

This is a typical approach to drawing and painting moving targets, because there simply is not enough time to get fussy with all the finer points of watercolour study. The brain needs to learn to memorize the essential elements of the scene in fractional time and then be able to rearrange them correctly on the paper. This skill will take a great deal of time to master, but having such an ability is really worth the perseverance. New York Central Station is a highly stimulating

* **EDIT** out any unnecessary elements when attempting moving targets. The handrails on the escalator merely pose an extra problem and their removal actually highlights bodily movement and adds a little extra interest.

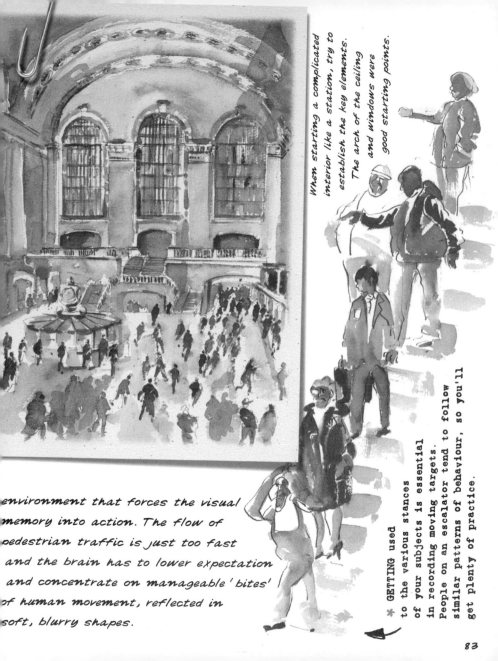

When starting a complicated interior like a station, try to establish the key elements. The arch of the ceiling and windows were good starting points.

...environment that forces the visual memory into action. The flow of pedestrian traffic is just too fast and the brain has to lower expectation and concentrate on manageable 'bites' of human movement, reflected in soft, blurry shapes.

\* GETTING used to the various stances of your subjects is essential in recording moving targets. People on an escalator tend to follow similar patterns of behaviour, so you'll get plenty of practice.

Find more animal subjects at your neighbouring farm, or visit your local zoo for magnificent wild species.

**ANIMALS** To translate the movements and essential character of animals and birds requires keen personal observation. The obvious place to find subjects is at home – here, sleeping pets make easy targets for painting. Other good places to sketch animals include the local pet shop, the neighbouring farm and the zoo.

Don't assume that you know how an animal moves: watch closely first. See how the joints often work in the reverse way to our own, and how the legs move in opposition to one another.

Use only a small selection of colours when painting animals in order to keep your attention focused on their overall shape and structure.

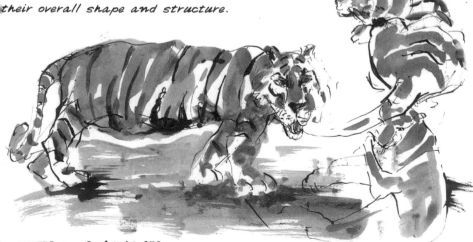

✳ TIGERS or elephants are ideal subjects because they slink and lumber slowly, sometimes almost freeze-framing, allowing you time to learn.

# PORTRAITS

Portraiture isn't just about copying an individual's details faithfully; it has as much to do with body position, tilt of head and neck and getting the mass shapes of body and head correct. Using a mirror, look at and feel your own bone structure. Run your fingers across the curve of the forehead to the flat plates of the temples, and then across the more prominent cheekbones. From here, touch the sunken sockets of the eye, over the eyeball and lids to the temple. Drop your fingers down to the chin and follow the jawline to the ear. Visualize not only the shapes, but also a range of colours to match: a cadmium red/yellow ochre tone over the facial area, lightening to a pale ochre on the raised surfaces such as the nose and darkening down with blue in the recessed areas such as the eye sockets. Try to see these as massed areas and fill the appropriate shapes with pigment. Start with the eyes and then relate the other shapes and their corresponding distances to this starting point. By measuring and relating all aspects of the face, you will attain a good portrait.

Senior citizens have wonderfully etched faces and sit very still.

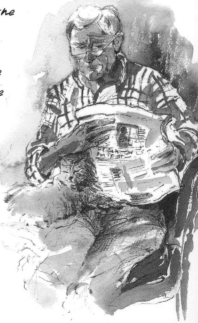

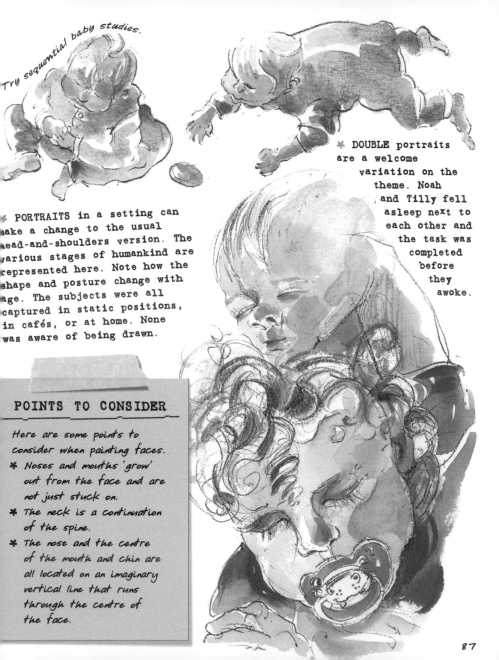

Try sequential baby studies.

* DOUBLE portraits are a welcome variation on the theme. Noah and Tilly fell asleep next to each other and the task was completed before they awoke.

* PORTRAITS in a setting can make a change to the usual head-and-shoulders version. The various stages of humankind are represented here. Note how the shape and posture change with age. The subjects were all captured in static positions, in cafés, or at home. None was aware of being drawn.

## POINTS TO CONSIDER

Here are some points to consider when painting faces.

* Noses and mouths 'grow' out from the face and are not just stuck on.
* The neck is a continuation of the spine.
* The nose and the centre of the mouth and chin are all located on an imaginary vertical line that runs through the centre of the face.

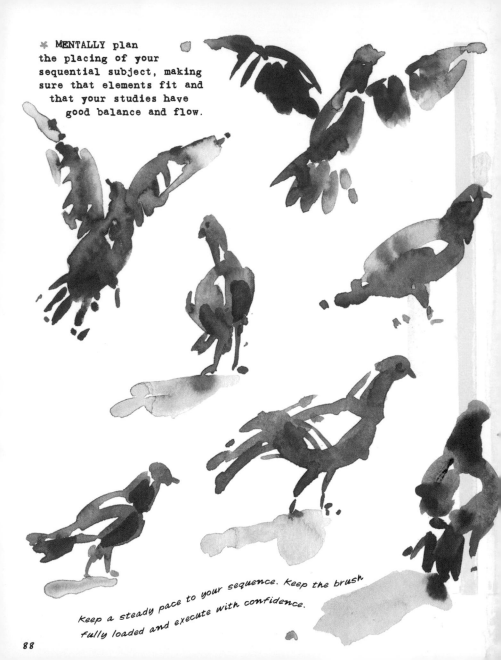

MENTALLY plan
the placing of your
sequential subject, making
sure that elements fit and
that your studies have
good balance and flow.

Keep a steady pace to your sequence. Keep the brush
fully loaded and execute with confidence.

# SEQUENTIAL STUDIES

Let your fully loaded brush dance over a double-page spread, recording a sequence of movements in life as it goes. This dash of freedom is a very good way of practising brush control and increasing your confidence and abilities with direct use of the brush. By altering the pressure on the brush, you can achieve a full range of marks, from the fine point through to the solid block of tone. The pigeon sequence was a spontaneous response to the movements of the bird as it landed in a local park on a summer's day. The smooth, spread-winged landing contrasted hugely with the jerky, staccato movements of the pigeon pecking for food and created interest for the studies.

Knowing that there would never be enough time to capture the swift movements with a combination of media led to the use of a single brush and two colours.

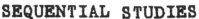

\* THE falling acrobat, recorded at a circus, tumbled with sleek body lines, which the single brush probably captured better than any other mix.

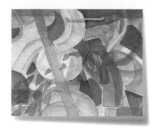

# COLOUR

'Speaking' with colour is a very powerful form
of communication. Fiery reds, with their high
concentration of pure colour, dangerously
dominate a picture, while blues help to bring a
sense of depth, calm and order. Whatever our choices,
they can assist in the unique creation of watercolours
displaying greater dynamics, changing moods, high levels
of transparency and the purity of individual pigments as
they change their colour value when added to one another.
To fully exploit these qualities is to be in control and
begin to understand the limitations (where they exist) of
the medium. The versatility of watercolour has inspired
artists to search for new expressions of colour while
holding on to the valued traditions of the past. We
decorate our homes with vivid colours chosen
from endless paint ranges, and it is no
longer just artists who show daring in
their handling of bold eclectic colours.
Further exploration into colour cannot be
recommended too highly.

*Where warm and cool colours are forced together, the reaction that is created can be one of volatility and unease.*

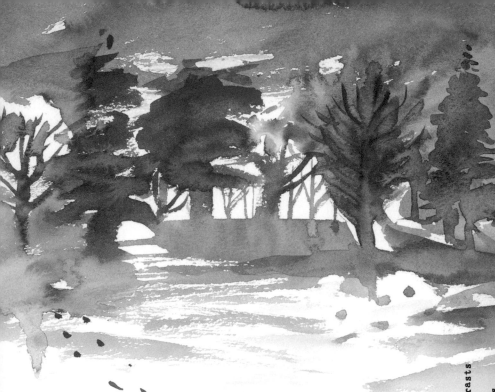

**MOOD** *Injecting red clouds into his landscapes gave the modern German watercolourist Emil Nolde a moody edge to his work. In an equally stunning way, the American nineteenth-century painter Winslow Homer used the cool blue range of colours to express the isolation of life in Maine or the Bahamas; symbolic of the American temperament, but always delighting in the awesome strength of the natural world. Of course, not all moods are gloomy or raw, and it is as valid in art to celebrate the positive aspects of life, with strong, bright colour and flourishing brush strokes, as the French Fauve painter Raoul Dufy did at the very beginning of the twentieth century.*

✳ COOL winter skies and the harsh contrasts of snow against the spiky evergreen silhouettes can create disquieting moods

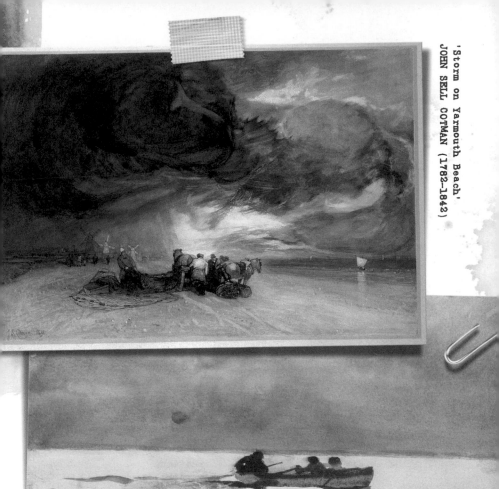

'Storm on Yarmouth Beach'
JOHN SELL COTMAN (1782-1842)

'Rowing Home' WINSLOW HOMER (1836-1910)

**MOOD** Strong, ghosting silhouettes of horses on the rolling hillside, set against the warm, dusky sky, created a dreamy mood perfect for describing in watercolour. Using a combination of wet-in-wet and wet-on-dry techniques, the picture was painted direct, with no pencil underdrawing. Under the setting sun, the land reflected a warm burnt sienna colour and the foliage on the trees became dark and shadowy. These were put in first to establish the simple composition. The ultramarine, cadmium red and cadmium yellow combination sky was then briskly applied so that it ran into the land, and, while the paper was still damp, the horses were dropped in. The bright white areas of unpainted paper helped to indicate the movement of the land and add sparkle.

Consider your moods, and
attitudes to life, and the
colours that best describe you
as a person. With no specific
subject matter in mind, create
mood pages in your sketchbook
using these hues and a choice
of brushes to create the
marks to match. On a day
when the mood takes you, visit
a location whose geography
suits your temperament – a
rocky mountainscape or stuffy
cityscape – and paint with the
colours used on your mood
pages. Better still, try to
match the colour and conditions
of the day to your choices.
Paint as you feel, and dare
to express your true feelings.

**EMERALD GREEN**

**PRUSSIAN BLUE**

**BURNT SIENNA**

**CADMIUM YELLOW**

# WORKING WITH A LIMITED COLOUR PALETTE

*Unsaturated colour washes create a subtle atmosphere, useful for
painting more low-key subject matter. Muted hues are made by mixing
primary colours with their adjacent secondaries, and harmonize perfectly
when combined with pure washes of pigment. The secret of success in
a limited colour painting is not to choose more than four colours.*

*The watercolour above uses only emerald green, Prussian blue, burnt
sienna and cadmium yellow; other shades are mixed as secondary and
tertiary colours. The painting opposite relies on limited colours to achieve
its aim. The tertiary washes have a calming presence in combination*

✳ LIMITED palette paintings work most successfully when kept minimal in every respect. Simple will always be successful, as shown in this painting of trees by a lake.

## PRACTICE

Create a collage that displays the mutable qualities found in watercolour. Stick small swatches of different papers or fabrics onto your paper to create an interesting base for this exercise. Fully exploit the different properties found in watercolour, perhaps by radically changing techniques mid-flow.

Lay consecutive layers of transparent colour onto transparent and opaque washes; include resists that add texture.

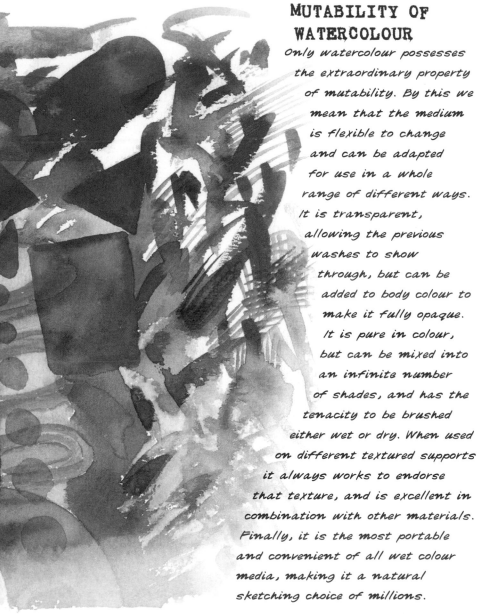

# MUTABILITY OF WATERCOLOUR

Only watercolour possesses the extraordinary property of mutability. By this we mean that the medium is flexible to change and can be adapted for use in a whole range of different ways. It is transparent, allowing the previous washes to show through, but can be added to body colour to make it fully opaque. It is pure in colour, but can be mixed into an infinite number of shades, and has the tenacity to be brushed either wet or dry. When used on different textured supports it always works to endorse that texture, and is excellent in combination with other materials. Finally, it is the most portable and convenient of all wet colour media, making it a natural sketching choice of millions.

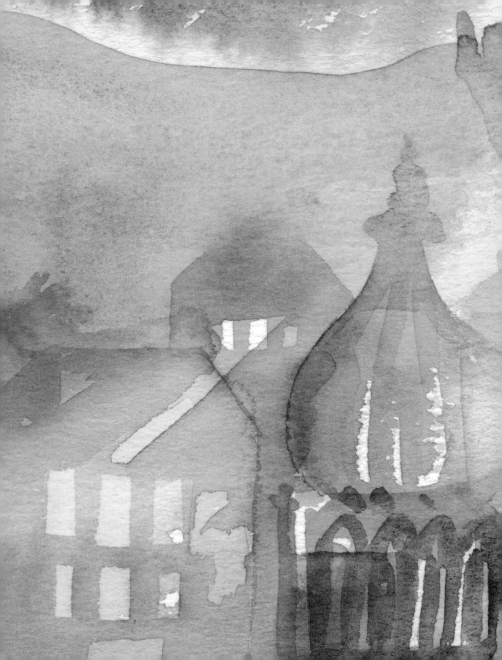

# LIGHT

Light is essential for life, and everything
we see and do is directly affected by it. If
we cannot see, then we cannot learn. Light is
fundamental to the artist, too. The fall of light
describes form and brings shapes to life before our eyes.
The cool receding colours near the horizon and the warm
advancing colours in the foreground are all due to the
reflected light of the sun as it hits objects within its
view or colours the atmosphere around us. Watercolourists
of the eighteenth and nineteenth centuries learned about
the nature of light as experienced through their visual
senses. John Cozens, Francis Towne, Thomas Girtin, John
Sell Cotman, J.M.W. Turner and Samuel Palmer all painted
with 'liquid' light, which intensified their perception
of tone, colour, temperature and rhythm. The traditional
method of underpainting grey washes was abandoned in
favour of allowing the brilliance of reflected
light to shine through. Today, its absence
would be inconceivable.

start to become more aware of light and then consider how the different
strengths of light convert into colour.

# PAINTING AGAINST THE LIGHT

Take a walk through the park on a sunny summer afternoon and face the lowering sun. You may notice that the leaves appear to glow across their whole surface, dazzling your vision. Any solid objects or figures will be subdued in colour, but not totally silhouetted. When this happens, the effect is known as 'contre-jour', literally meaning 'against the day', The most stunning effect is a rim of light or a soft halo around the object or person; when set against bright sunlit background tones, this will help to give a very three-dimensional depth to your sketch. Although soft in quality, the compositional objects possess strong contrasts of light and dark. Not only do these properties present a bolder, more attractive design, but they also bleach out any fiddly, unnecessary details that would overcomplicate your task.

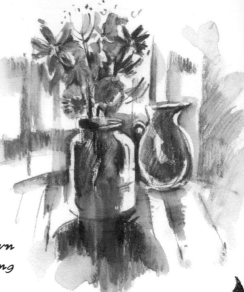

✳ CAPTURE contre-jour by placing interesting objects on a sunlit windowsill.

## PRACTICE

When sunlight streams through a window, try contre-jour using the sill and frame as a viewfinder for your drawing. Place interestingly shaped objects by the window and observe the halo effect. Build up subdued washes of colour, being careful to retain the subtlety in the shadows, and allow the whiteness of unstained paper to give maximum contrast.

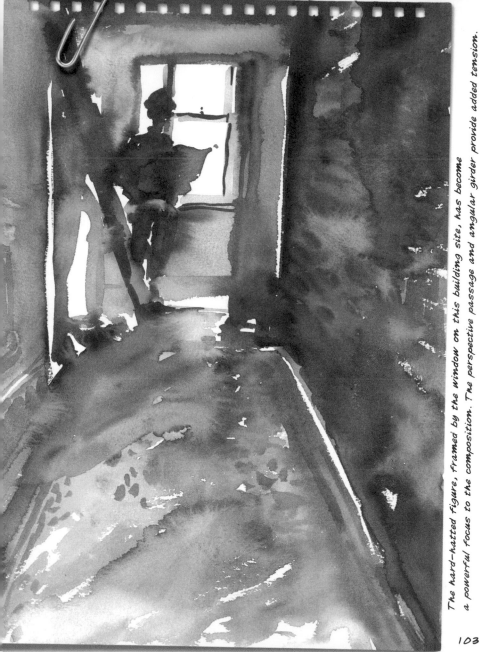

The hard-hatted figure, framed by the window on this building site, has become a powerful focus to the composition. The perspective passage and angular girder provide added tension.

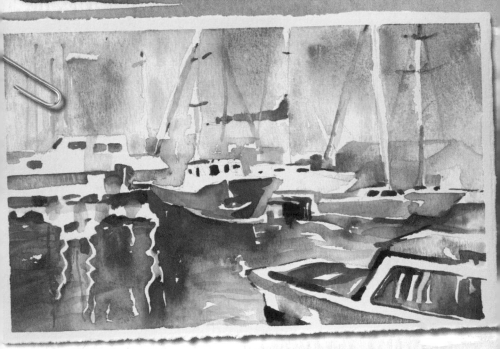

<b>* BARE</b> white paper is crucial
in retaining the sparkle of
reflective studies.

# REFLECTED LIGHT

*Look into a pond or lake on a calm day and observe the perfect example of reflection in the still surface of the water. The reflected light produces a mirror image of the bank at the water's edge to about the same depth, and the water appears to interrupt the continuation of it as it passes beneath the surface. When the water is rippled, the light reflection is distorted. Light reflection also appears on non-transparent objects. A white house will best reflect the colour of the green shed next to it, and the wall of the house will appear to be the same colour green. If the same house were*

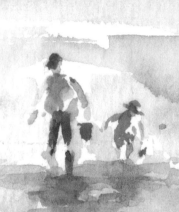

painted red, however, the reflected light of the shed would mingle with the red wall, producing a brown hue.

   On strong sunlit days, reflected light on the surface of the sea or sky can throw off a dazzling glare, making everything around appear bleached of colour and much brighter. Where there are strong colours in the proximity, they will seem even stronger. Bear this in mind when you are painting under these conditions and use strong, pure pigments to stunning effect.

✱ CHOOSE your day carefully. Bright, sunny days will ensure that you clearly see the reflections in sky and water.

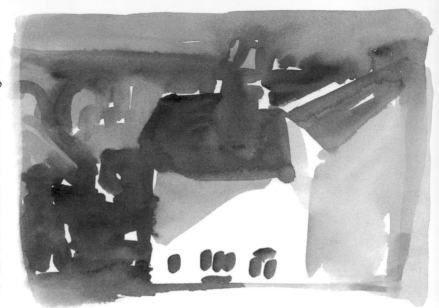

## CHANGING LIGHT

The scene you have chosen to paint can change dramatically in a matter of minutes. Cloud cover removes long winter shadows and the dull, flat reality before you may no longer bear any resemblance to the picture you have produced.

Perhaps the answer to this problem lies in a small sequence of fresh studies made within an hour of one another. Winter light just before sundown is a good time, because the changes are fast and significant. To reap the full benefit, remain in the same place for the duration of the series and make sure that the view has a strong foreground to form a reference point to focus the eye. Divide your paper into four equal parts, or use four equally sized pieces of paper. If necessary, roughly set the key elements in place using a pale pencil sketch and then apply increasingly dark washes as you progress. To keep the sketches alive, try not to spend more than twenty-five minutes on eac

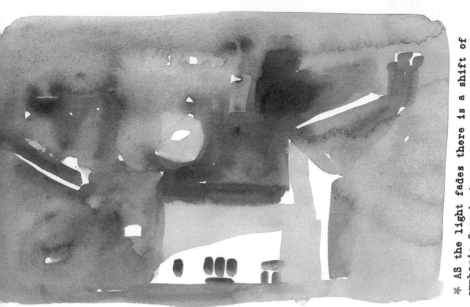

* AS the light fades there is a shift of emphasis from background to foreground.

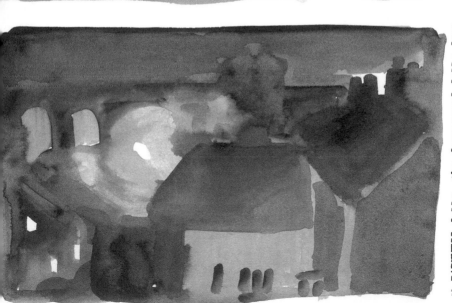

* DARKNESS falls, the foreground dulls down and the whole scene is visible.

107

# LIGHT AND TRANSPARENCY

*In its transparent state, watercolour paint relies on the fact that light rays pass through its layers to the paper surface and are then reflected back to the viewer. The heavier the washes, the less light reflects back. Opaque watercolour, known as gouache, is too dense to allow light to pass through it, and is reflected from the surface of the paint itself, making it appear very flat.*

*In this study of bottles and fruit, the colouration was exaggerated to heighten the feeling and brightness of the transparent light. Sharp edges and defining borders were deliberately left ambiguous so that colour just mingled together to describe the transcendental nature of light. The textured, granular areas of pigment occurred naturally on the rough paper, but similar effects can be achieved by sprinkling a little salt on the area.*

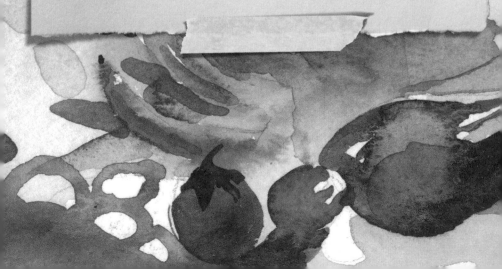

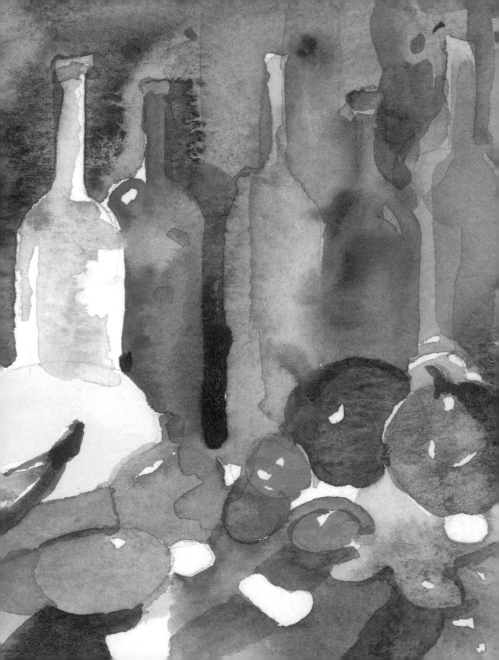

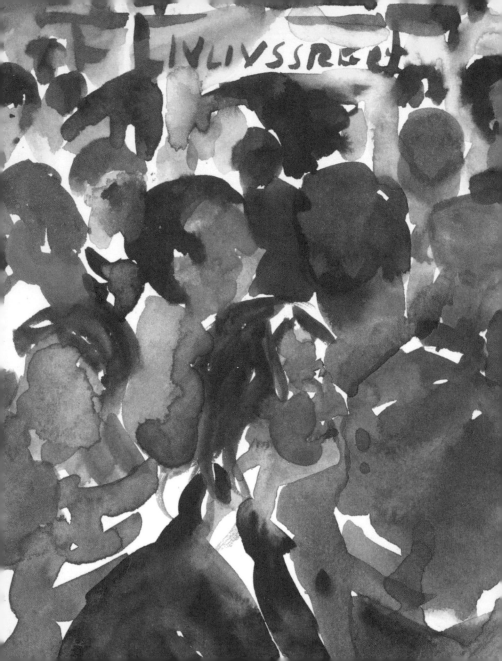

# SKETCHING ON THE MOVE

The buzz experienced when sketching on the move is not felt in any other watercolour discipline. A degree of risk is always present as you try desperately to sketch the moment passing before you with accuracy. The eye scans, rests, makes value judgements and draws within seconds. It takes courage and practice to train the brain to record the 'snapshots' of life, but the lessons learned will feed every area of your painting and leave you in good shape for further artistic pursuits. Do not set your sights too high at first. Failure will be inevitable at times, because life in action won't hang around long enough for you to create the master strokes. Once accepted, the challenge of capturing figures at work and leisure can be really stimulating, even compulsive! Animated sketchbook spreads become treasured pages of an ongoing journal, which serve as a useful historical document, a memory jogger or a simple record for posterity's sake.

*Wet tints of colliding colour can recreate the impression of human movement, as seen here in Rome.*

# SKETCHING ON HOLIDAY

Tickets, passport, sketchbook and prepare for take-off. Your holiday has begun! A few simple tips can prevent you from staggering onto the check-in scales like a beast of burden with excessive materials you just don't need. Travel lightly and make do with the barest essentials. A watercolour box, a few favourite brushes, pens and pencils, a small water pot, pocket sketchbook, medium-sized pad of paper, camera and perhaps a resist material or two should be enough to see you through a couple of weeks in a foreign place. Unless you are in the middle of nowhere, you should be able to find an art shop or stationery equivalent to stock up on emergency supplies. Make sure that you have suitable clothing and comfortable footwear for your destination, with just a few extra layers and some waterproof

\* THE viewing window of an airport lounge can ease you into holiday sketches.

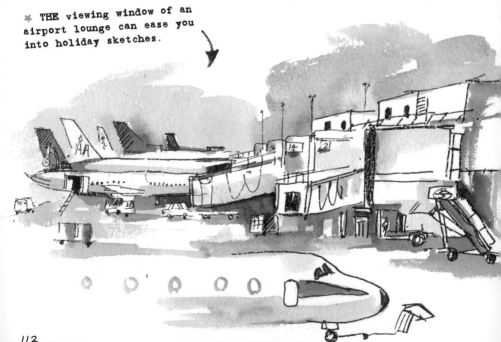

❊ OBSERVING cultural iden-
tity is key to capturing the
essence of a foreign visit.

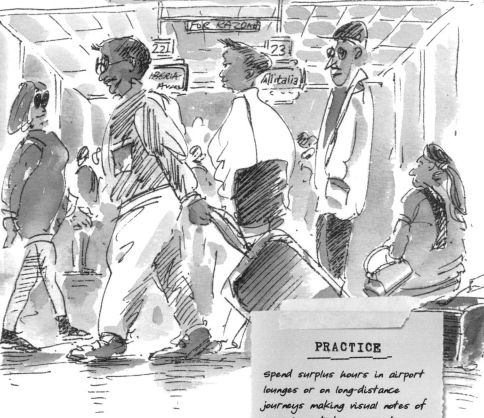

clothing packed for times spent
out on location as a precaution.
Carry everything in a compact
rucksack, or case if you prefer,
and for carry-on luggage on
the plane you might want to
consider a lightweight folding stool.

## PRACTICE

Spend surplus hours in airport
lounges or on long-distance
journeys making visual notes of
your immediate surroundings.
Capture the mood of waiting
travellers, explore the difficult
perspectives of the aircraft
cabin, gather those first
impressions of a new country.
Be prepared for the realization
of how quickly time flies!

# THE TRAVELLER'S SKETCHBOOK

*Why not pass 'dead' time spent on train, plane or bus journeys sketching your immediate surroundings and exterior locations? Seating rows and long corridors give added depth to compositions in this stimulating pastime. The jolting movements or rocking rhythms can be used to your advantage, creating a nervous, energetic study, bearing all the hallmarks of spontaneity and transience experienced on a typical journey.*

*Train your memory to observe the posture and expression of fellow passengers without having to stare. For every three fleeting glances, draw once! Always respect people's privacy. The result will be far from perfect, with staccato pencil jabs and splotches of colour genuinely expressing a real pictorial expedition. The sketchbook you keep should be adapted to suit your painting needs and be large enough to comfortably draw in, but small enough to easily carry around with you. Hardcover books are worth the extra investment because they are far more durable.*

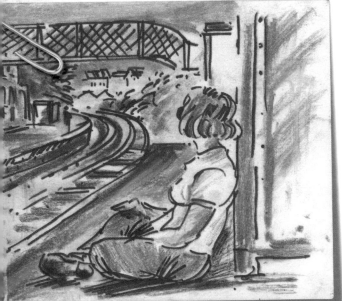

✳ DIFFERENT travel settings have objects and ephemera peculiar only to that mode of transportation. Take time to record railroad tracks, platforms and iron girder bridges.

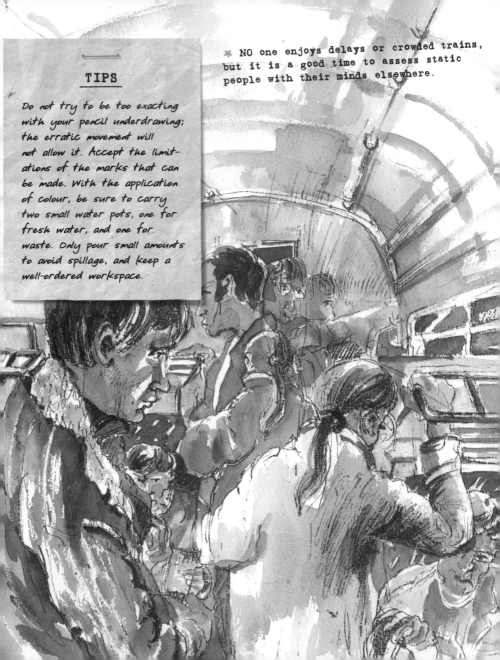

## TIPS

Do not try to be too exacting with your pencil underdrawing; the erratic movement will not allow it. Accept the limitations of the marks that can be made. With the application of colour, be sure to carry two small water pots, one for fresh water, and one for waste. Only pour small amounts to avoid spillage, and keep a well-ordered workspace.

❋ NO one enjoys delays or crowded trains, but it is a good time to assess static people with their minds elsewhere.

**REPORTAGE** *Reportage is visual journalism – telling the story through pictures. In the 1950s and 1960s it was validated as a fashionable method of reporting in newspapers and current-affairs journals. The watercolour illustrator Paul Hogarth drew for the popular 'Fortune' magazine, Ben Shahn sketched life in the American ghettos and in Europe, Feliks Topolski recorded notable royal engagements and political events. The result is a more personable and subjective set of pictures, which is made interesting by the 'colour' of the artist's own attitudes to the subject. Good reportage requires shrewd selection of the 'facts' as they appear, and then clear assemblage of the most important parts of the 'story'. A composition that is not clear may have too many elements or insufficient focus on the*

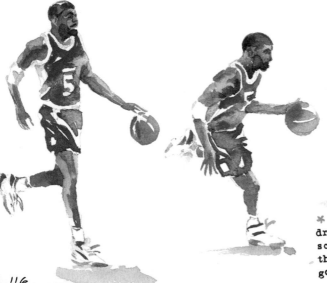

＊ A BASKETBALL player dribbles, leaps, then scores into the net. A three-image sequence makes good reportage material.

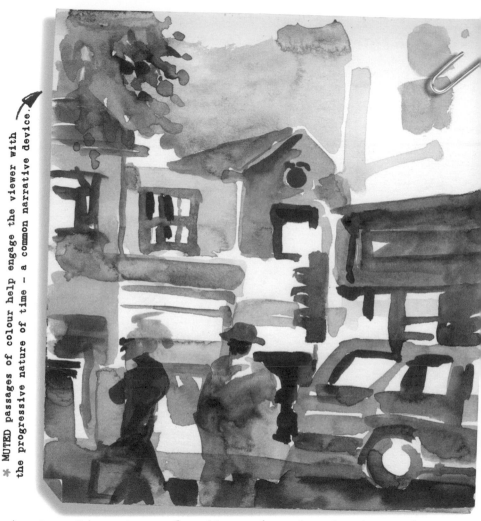

* MUTED passages of colour help engage the viewer with the progressive nature of time – a common narrative device.

main area of importance. Consider scale and contrast, cropping with the viewfinder and the principles of good composition when creating a piece of visual narrative. Remember, it does not need to be highly detailed to make the point. A few brush strokes could say all that needs to be said.

# RAPID SKETCHES IN AWKWARD SITUATIONS

When caught without the necessary tools for the job, learn to improvise with whatever is on hand. Sharpen a stick, dip it in ink and use it to make marks that are scratchy and immediate and a natural companion to smooth watercolour washes. Coffee and tea are worthy stainers of tonal pictures, and red wine dries to a seductive pinkish-red hue.

Sketching while walking, although not easy, is wholly attainable. Watch where you are going and keep looking at the subject matter. Pen or pencil marks should be made in swift-flowing movements, and where figures are involved, draw the contour of the whole person before adding any small detail. Mud works well as a natural earth pigment and its dry texture is best applied with the tip of the finger or a rag.

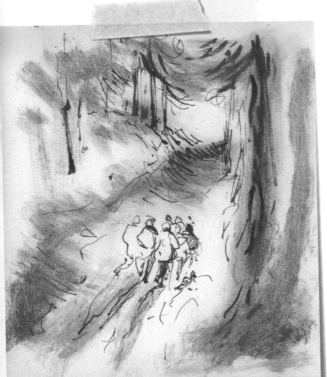

If you find yourself sketching in an awkward or uncomfortable place, such as a large crowd of people, it might be best to get as much information down as quickly as you can, with notes of colour to use written in lightly and then tint it later on according to your guide.

✱ A New Year's walk in the country with relatives - a must for the family album. Penned while walking, it was tinted with local mud.

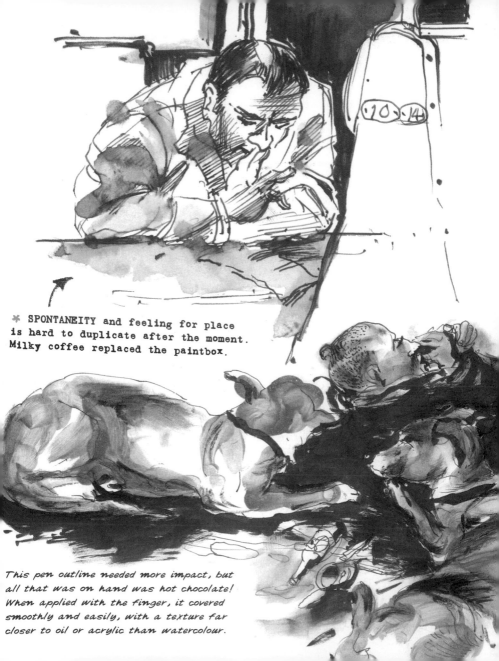

* SPONTANEITY and feeling for place is hard to duplicate after the moment. Milky coffee replaced the paintbox.

*This pen outline needed more impact, but all that was on hand was hot chocolate! When applied with the finger, it covered smoothly and easily, with a texture far closer to oil or acrylic than watercolour.*

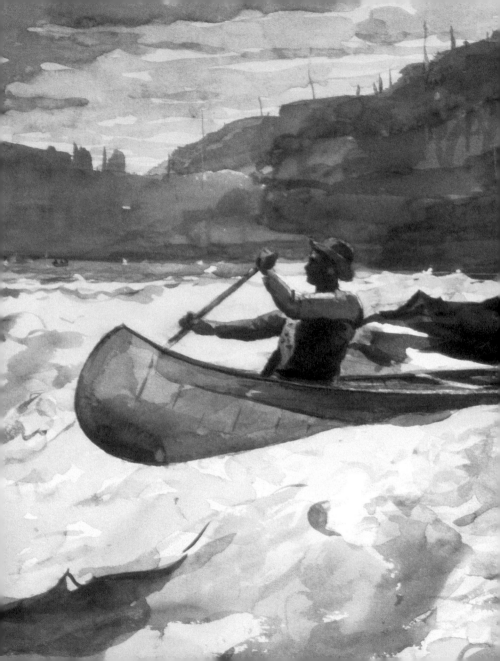

# LEARNING FROM OTHERS' WORK

Nothing under the sun is truly original, in so far as we have all been conditioned by circumstance, influenced by elders and learned from past civilizations. With painting, too, we are influenced by what we see, both in the real world and in the subjective worlds of other artists' work. We admire another's art and stare into it in the hope that we might one day see something of its quality and content in our own. Fortunately, the legacy of past art is rich and varied, and we can draw from a vast range of eras and styles for our inspiration. The present also holds in store a great deal of inspiration for us; when we open our eyes wide and look around, there is plenty of interest to influence our thoughts and shape our creative minds. The key to ongoing success and enjoyment is never to stop looking and querying the world in which we live. Artists will sit idly wondering what to do, for theirs is the job of unravelling the meaning of life, visually.

WINSLOW HOMER, Shooting the Rapids (1858-1910)

# LOOKING FOR INSPIRATION

Turn a corner and prepare to be thrilled by a new discovery. The best subjects for painting are seldom in the obvious places and you may have to spy with curiosity in order to find them. If you are moved or stimulated by something that you see, investigate more thoroughly and consider it a likely subject of inspiration. Keep an open mind and don't allow yourself to get stuck in the rut of painting what you know you do best, or in the ways that you find easiest. A day spent gazing at the Old Masters in art galleries, or even at tiny reproductions in library books, will do no harm where gaining inspiration is concerned.

Travelling to unfamiliar places and observing different cultural behaviour, architectural styles, colours and climate can trigger fresh inspiration. Sitting in a tourist restaurant with fellow travellers, safe in a place you recognize as a home from home, will not necessarily present you with the best subjects for locational sketching. Instead, follow the locals to their small intimate bar, and watch the old men playing cards, joking, chatting and simply letting

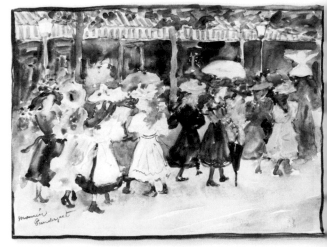

'Watercolor of Girls Walking Along the Boardwalk'
MAURICE PRENDERGAST (1858–1924)

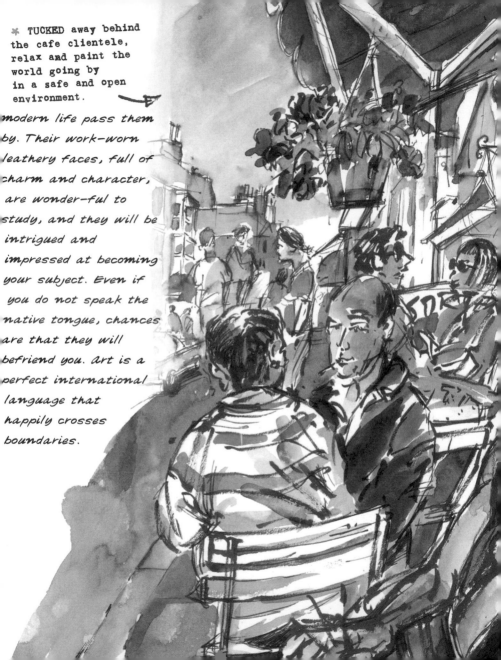

✳ TUCKED away behind
the cafe clientele,
relax and paint the
world going by
in a safe and open
environment.

modern life pass them
by. Their work-worn
leathery faces, full of
charm and character,
are wonderful to
study, and they will be
intrigued and
impressed at becoming
your subject. Even if
you do not speak the
native tongue, chances
are that they will
befriend you. Art is a
perfect international
language that
happily crosses
boundaries.

# THE LANGUAGE OF WATERCOLOUR

Watercolour as a 'language' makes beautiful sounds and flows with poetic rhythm. It can be soft as a whisper in its tone, or as shrill as a high-pitched scream, and easy portability makes it the number-one form of shorthand among diarists and note-takers.

Develop your very own form of shorthand based on the guidelines and disciplines learned from this book and other sources. As you become more fluent, the marks made will begin to reveal a personal, handwritten style. The ability to make reference to technical terms and styles of artists,

* REFINE brush strokes into a new, deliberate 'alphabet'. The organic tree and plant forms make especially good subjects.

124

both past and present, in a simple way that can be understood by all should never be overlooked. Van Gogh's preliminary sketches of harvest fields show an inimitable shorthand style, used only by him, but now universally understood by all. The idiosyncratic scratches, cross-hatches, dots and flecks all read with clarity when constructed into visual 'sentences'.

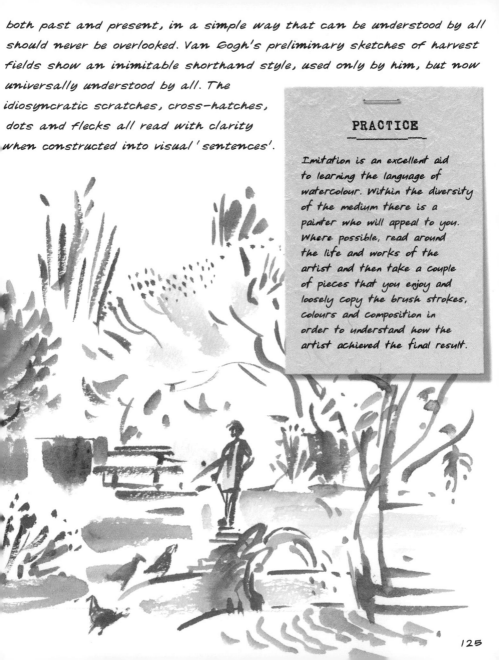

## PRACTICE

Imitation is an excellent aid to learning the language of watercolour. Within the diversity of the medium there is a painter who will appeal to you. Where possible, read around the life and works of the artist and then take a couple of pieces that you enjoy and loosely copy the brush strokes, colours and composition in order to understand how the artist achieved the final result.

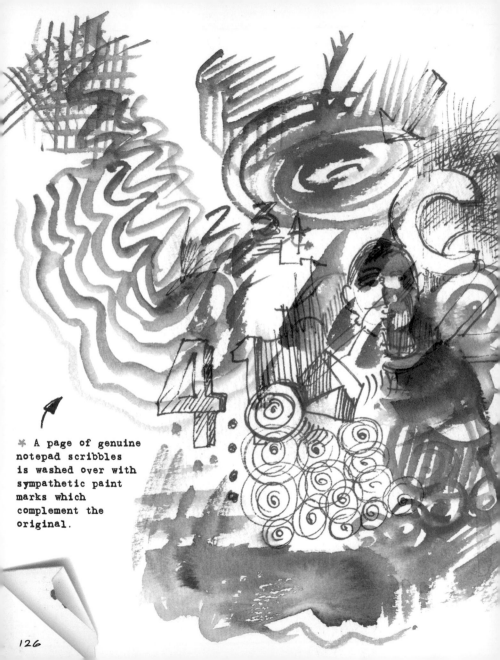

✳ A page of genuine
notepad scribbles
is washed over with
sympathetic paint
marks which
complement the
original.

# THE LANGUAGE
## OF WATERCOLOUR

The phone rings and in conversation rapid doodles erupt from a semi-conscious mind onto a scribbling pad. They flow as naturally as the dreams of night and, being rooted in the depths of the inner self, cannot easily be explained. Strangely enough, they are often the freest, most interesting of all the marks we make, and not being bound by convention or attached to specific intention, they have the useful characteristics of spontaneity, accident and chance. Now ready to be taken up and expressed through the hues of your palette, these new marks will almost certainly alter the look of future creations without removing your overall stamp of recognition. The natural inclination for repetition might even lead you to explore pattern-making.

✴ SIMPLE experiments with directional lines give a sense of power, dynamic and pattern.

## PRACTICE

Keep doodles and idle scribbles in a safe place. When you have collected a variety of examples, check them against the shapes and movements of the brush strokes you use. Are there similarities? Where differences occur, might these doodles be usefully adopted into your painting vocabulary? Translate them onto fresh sheets of paper using dynamic colours, and enlarge them to see how a change in scale affects their visual presence and meaning. Adopting doodles into your learning processes will help to broaden your thinking and physical approach to watercolour painting.

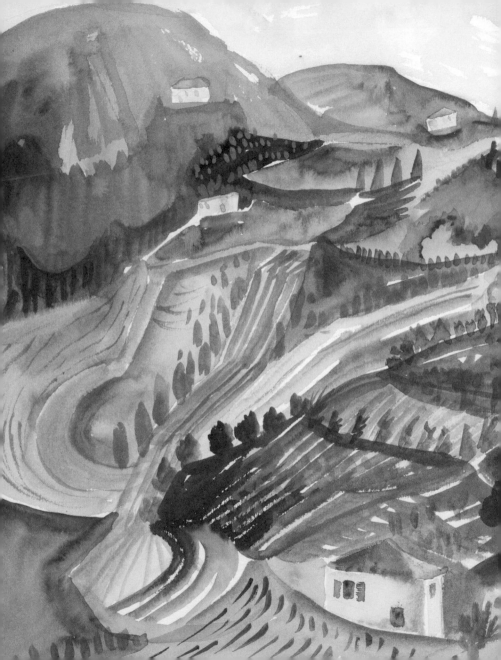

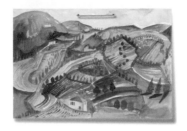

# DEVELOPING YOUR OWN STYLE

Never allow yourself to get hung up on style. It is far better to make pictures that are led by your own enthusiasm for the subject, packed with well-edited, organized elements, than those driven only by universally copied styles. Watercolour, with its many weird and wonderful techniques, can tempt you into 'mannered' ways of painting and sketching using the same shapes, forms and effects every time, regardless of subject matter. Another risk is developing a slickly superficial style that produces reasonable-looking work at first glance, but on further investigation reveals itself to be overgeneralized and lacking focus. To help avoid such pitfalls, seek the elements of the scene before you that seem to make it unique. Then decide, from your developing vocabulary of personal marks, how best to describe them. Try not to compare yourself with others, accept who you are and value your own self-expression as it begins to bloom.

# THINKING LIKE AN ARTIST

Get into the habit of thinking like an artist. Be inquisitive and make visual judgments wherever you are. Search for the particular, rather than the general, and attempt to portray an apparently ordinary world in an extraordinary way. Paul Klee considered his art to be an analogy of nature, and Pablo Picasso slavishly searched for new subjects to be expressed in new ways; both lived life through their art as a natural extension of personal philosophy and thinking.

To think like an artist is also to translate thought into pictorial images. Initial ideas must be developed on paper if they are to be refined and honed into a useful and effective form of communication. The barest jottings could be the seedlings of a mature crop of work.

The watercolour notes shown here are all studies of shape and movement in typical

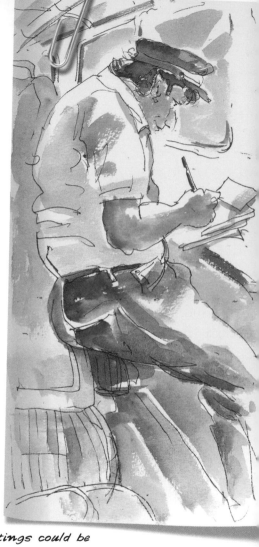

\* QUICK decisions had to be made when sketching the guard. 'On the spot' fines are issued rapidly!

Figures that can be found in the everyday routines of urban life. In themselves, they do not constitute any great work of art, but they are of invaluable assistance to a series of pictures centred on the hustle and bustle of the city. In their own right they offer a great insight into the mind of the artist.

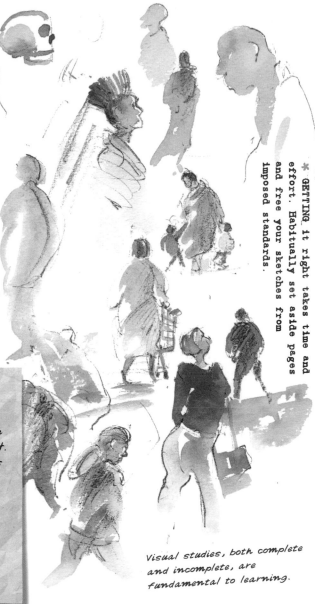

* GETTING it right takes time and effort. Habitually set aside pages and free your sketches from imposed standards.

## TIP

It can be hard to appreciate your own curve of development. Date all paintings and studies and get an honest, trusted friend to periodically look through your portfolio and offer encouragement or critical advice. They will be far kinder to you than you are to yourself.

Visual studies, both complete and incomplete, are fundamental to learning.

# THE PLANNER'S SKETCH

Take heart: no artist gets every composition right first time. It is often necessary to make planning sketches in advance of a final study to iron out inevitable problems or to rehearse the use of space, techniques and colours. This unfinished watercolour sketch was one such example, employed to help solve a number of visual problems in the scene. The beach was viewed on a crowded summer's day, and the whole place was a blur of detail and activity — even the cliffs receding into the distance were sharp in the clear light of bright sunshine. But it was the interactive human activity that aroused greatest interest and this was chosen as the focus. The sketch shows practice attempts at figures, all drawn directly with the brush; the warm-palette pigments are watered down to see how different densities of colour outline alter the depth and balance of

* A typical planner's sketch reveals much about the artist's working methods and leads to a more successful final piece.

the composition. To avoid conflict of interests, the midground and background were broadly brushed with fluid wet washes of strong, cool colours. Triangular spaces were left on the paper, where sailing boats were intended.

Changing light and cloud cover led to the decision to paint the sky on the actual painting al fresco.

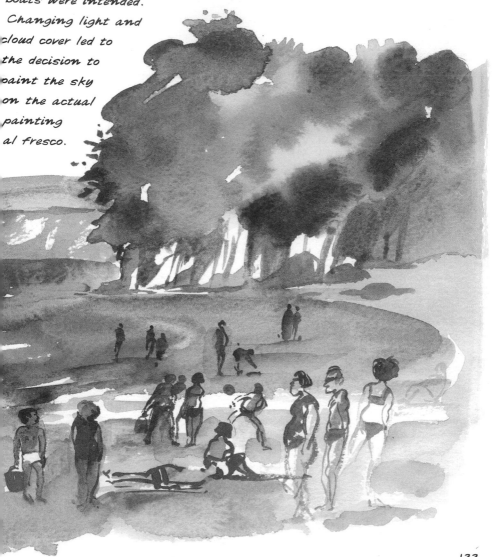

# USING SKETCHBOOKS TO
# BRING IDEAS TO FRUITION

Sketchbook spreads are ideal for bringing the
flow of creative ideas to fruition. The relaxed
format of the centre-folded pages removes
the 'precious' urges that a blank white sheet
can engender. Be fluid in your thinking and
mark-making, allowing
the paper to be filled from
edge to edge with a
sequential development of
problem-solving sketches.
Making a habit of this
practice will greatly
improve your watercolours.

Test as many
different possibilities as
you reasonably can until
satisfied with your choice.
Colour and composition
both need to be addressed
in this important
exercise. Keep going until
you have solved all visual
problems and try not to
lose touch with the
spirited nature of these
studies, when creating
a final painting.

Equal balance lacks impact.

The vases overshadow the cat.

Full in the frame works best.

* USING pencil and wash, the cat (drawn in two different positions) stands out from its pure wash setting.

* THE user-friendly working sketch should be informative, clear and provide all the solutions to the visual problems encountered.

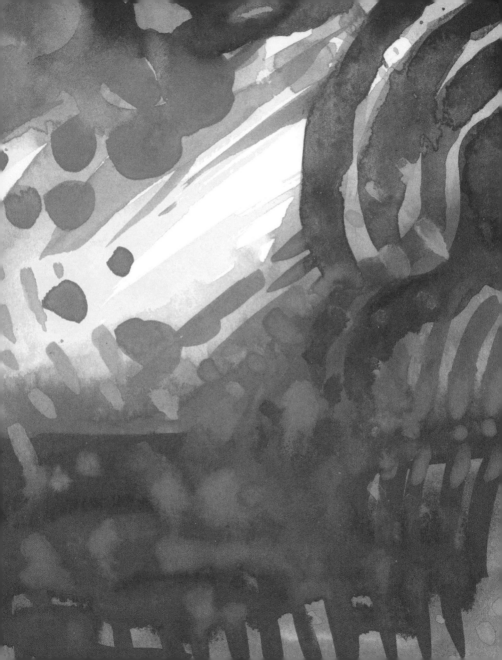

# SKETCHING FROM
# MEMORY AND IMAGINATION

With the basic rules of watercolour painting in place,
you can start to unleash the power of your
memory and imagination into your work. If you
draw from static objects, then the memory only
has to retain the information it needs for a
second or two before further investigation. But
by extending the time taken to look, you can train the
visual memory to recreate what is no longer in front of
you. Add a little artistic interpretation to the mix and
you will soon find yourself working from the imagination.

Drawing from within yourself is a whole area of study
in its own right. Most artists (abstract ones included)
paint from direct experience of the real world, but some
are fascinated by fantastic creations of the mind or
dreams and find it a huge source of inspiration and
exploration. Involving your imagination can
take you from the mundane world into a
more idealized place, and such escapism
can be very satisfying indeed.

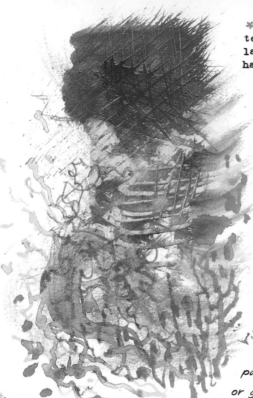

※ DRAGGING pigment through the teeth of a comb, wet and dry, and layering using a plastic bristle hairbrush made these exciting marks.

# EXPERIMENTING IN WATERCOLOUR

Art has now reached a point where anything goes. The set conventions that used to protect separate disciplines of painting have been eroded by the cross-fertilization of different media, coupled with new waves of thinking. Watercolour no longer has to be painted on paper or cloth, polystyrene or glass are equally valid in the search for new expression.

The use of more daring marks and rogue colour combinations has grown consistently throughout history. In the 1920s, John Marin pushed the approach of Winslow Homer into a form of Impressionism bordering on the abstract. Georgia O'Keeffe further developed this, and in the 1950s Sam Francis became the watercolour equivalent of Jackson Pollock, leaving the door wide open for the future. Watercolour will always remain outside the changing dictates of fashion in artistic movements – a stain of pure pigment will always be considered beautiful for its own sake.

Sometimes experimentation supplies the need for a specific technique to mirror the texture of an object.

Move your painting forward with unconventional and experimental methods. Print textured patterns onto areas of your composition using bubble wrap or foliage from plants. Use foam rollers, cloths and sponges to give marks of differing qualities, and hunt down other domestic objects whose texture will create something interesting and new.

✳ THE popular summer refreshment kiosk at Southover Grange Garden in Lewes became the focal point for this experimental composition. The foliage is actually printed from leaves and branches gathered on site.

## ABSTRACTION AND FREEDOM

Abstraction is often the final destination for the life's journey of an artist, having begun with a formal training grounded in representational art. The shedding of formalities marks the artist's yearning to move forwards to a new state of thinking and practice. Paul Klee took his 'line for a walk' into complex compositions of shape, form and colour, where aesthetic values and the power to express rhythms and moods gave his work the edge over more realistic interpretations. By practising abstraction, we are in a better position to accept the work of those who choose its route. True freedom exists in the brain and does not just inhabit the world of the abstract artist; thus a tightly controlled, realistic watercolour might be as free in its concept as a splashy abstract.

There is room for both abstract and figurative to co-exist happily in watercolour painting, a notion fully respected by the free-thinking mind.

✳ TO move into abstraction is to cut loose the chains of convention and experience a new-found freedom.

## PRACTICE

Look at a group of forms as they exist in nature and decide which shapes and colours have the greatest visual significance. Design these into a composition, manipulating and exaggerating them to create a dynamic composition. Do not be tempted into recreating an illusion of the reality before you. Try altering the scale and colour of the shapes, too.

It may seem child's play, but successful rhythms and composition are harder to achieve than they look.

✳ NOW grounded in the primary principles of watercolour painting, you should feel more confident to approach the open subject of abstraction.

141

# INDEX

# ACKNOWLEDGEMENTS

The author would like to thank Tilly Tappenden and Isabella Northrop for their illustrations on pages 34–35.

The publisher would like to thank the following for the use of pictures:

✻ The Art Archive: 38 (The British Tate).

✻ The Bridgeman Art Library, London: 32 (National Gallery, Berlin); 33 (Private Collection); 62 (The Victoria and Albert Museum, London); 93T (Norwich Castle Museum/Norfolk Museum Services); 93B (Private Collection); 120 (Brooklyn Museum of Art, New York).

✻ CORBIS/Geoffrey Clements: 122.

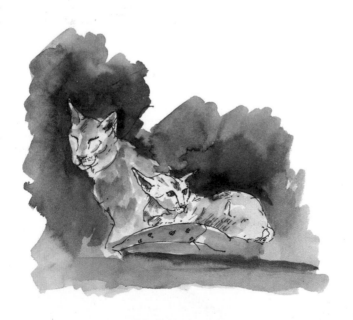

*I ractical*
# WATERCOLOURS

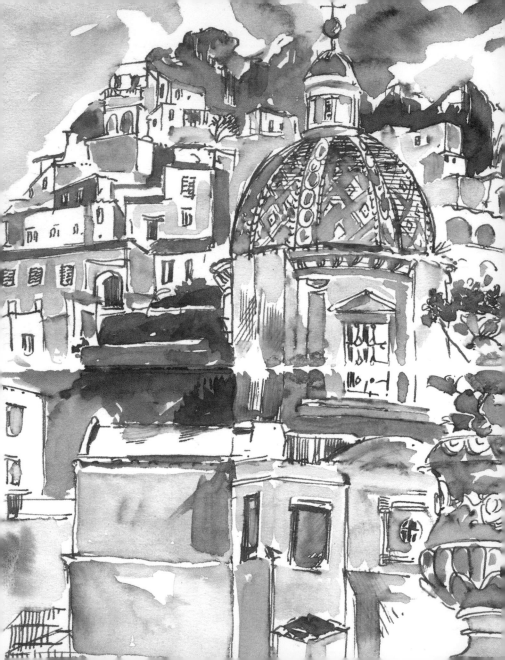